THE ARTIST'S GUIDE TO
DRAWING
MANGA

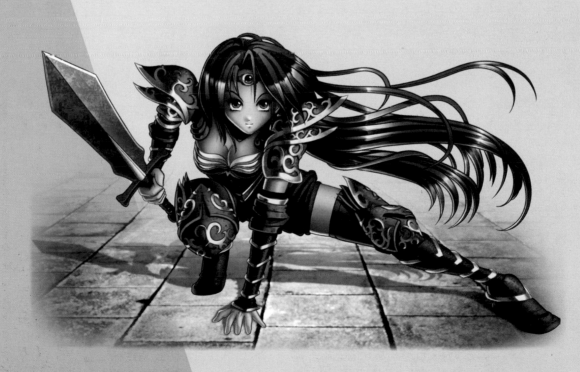

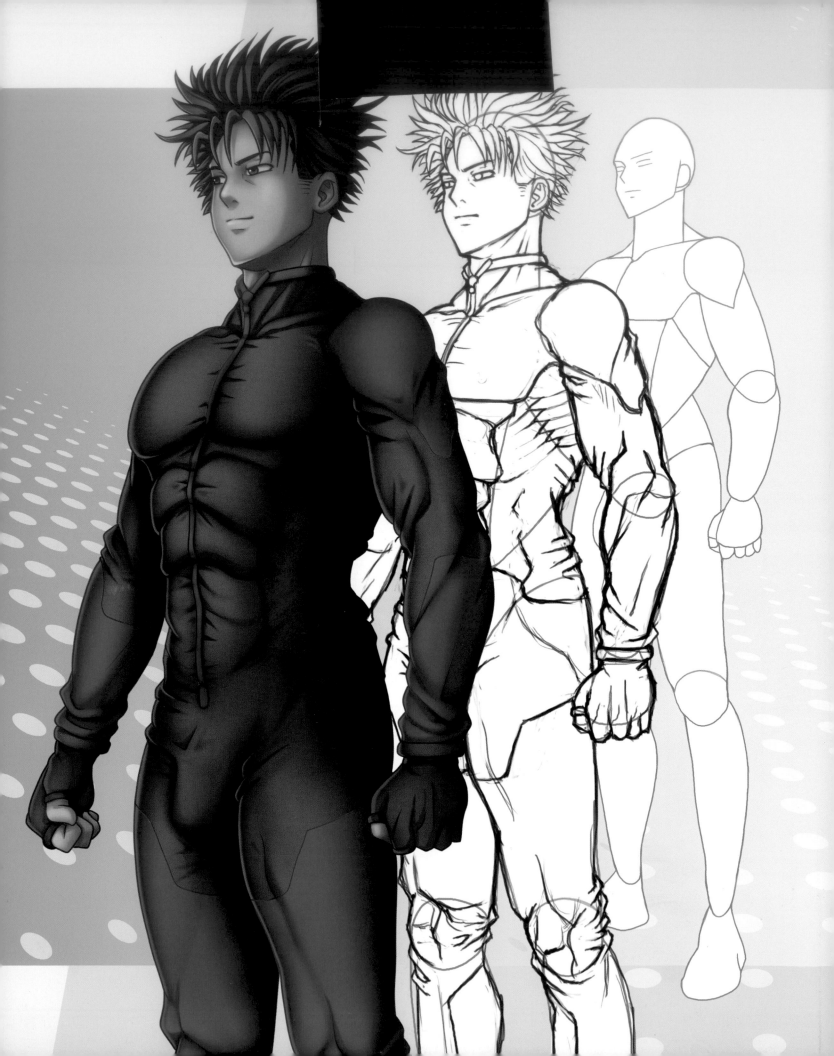

THE ARTIST'S GUIDE TO
DRAWING
MANGA

TECHNIQUES • CHARACTERS • STYLES • DIGITAL

BEN KREFTA

ARCTURUS

Ben Krefta is a UK-based freelance
illustrator and graphic designer whose
unique and unconventional designs are
primarily targeted at edgy, tech-savvy,
video game-playing, manga-reading
teens and young adults. He has worked
on a number of art and design projects
for websites, game developers and
magazines and has delivered digital
art demonstrations for clients such as
Hitachi and Wacom. He is also the author
of a number of bestselling how-to-draw
manga books. For more information, visit
his personal homepage,
www.benkrefta.com

Arcturus

This edition published in 2016 by Arcturus Publishing Limited
26/27 Bickels Yard, 151–153 Bermondsey Street,
London SE1 3HA

ISBN: 978-1-78404-644-6
AD004808US

Printed in China

CONTENTS

Introduction

'Manga – it's just a fad, isn't it?' said one of my art tutors at university back in 2006. When I was growing up in the 1990s, anime was starting to gain popularity among Western teenagers and young adults thanks to companies such as Manga Entertainment in the UK and U.S. Manga Corps in the USA, which imported many of the popular animated series from Japan. Soon after, comic and book stores began stocking the manga comics from which many of these animations originated. In the next decade the internet became a staple part of people's lives and fans could easily connect with each other across the globe, sharing their enthusiasm for these modern Japanese themes, art styles and stories.

Manga and anime artwork is becoming increasingly assimilated into mainstream books, TV, games, movies, fashion, design and advertising. Unlike my tutor, I can't see the art form disappearing any time soon – in fact it continues to increase in popularity, with a new generation of fans discovering its exciting stylistic qualities for the first time in the 21st century.

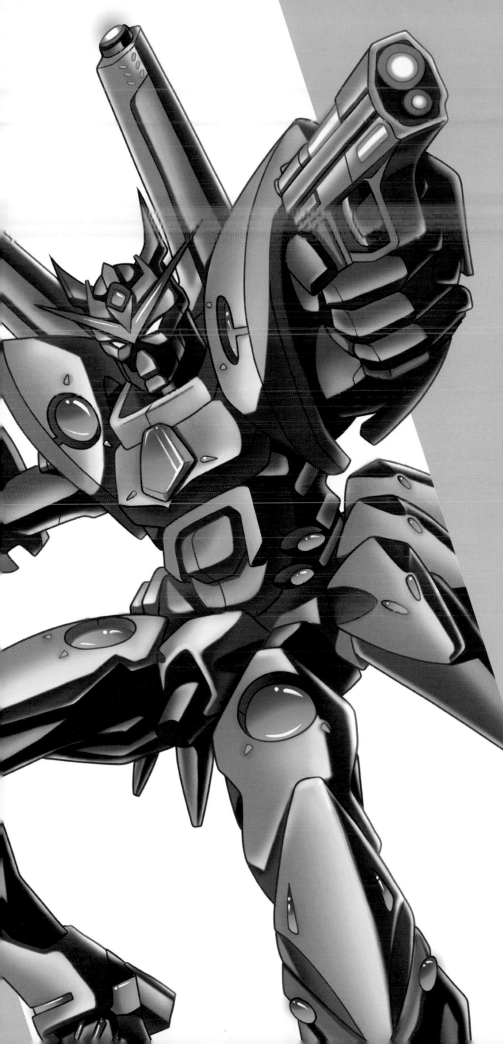

WHAT ARE MANGA AND ANIME?

Exciting, mesmerizing, simple yet complex, manga and anime are forms of visual storytelling for all ages. Manga is a term that describes comics produced by Japanese *mangaka* (manga artists), primarily for a Japanese audience. The style was developed in Japan through the mid to late 19th century with heavy influence from Western and American comics combined with the long and complex history of Japanese art and wood-block prints. In the Western world, the term is often used more broadly to mean a style of drawing originating in Japan and many Western artists who have adopted the style refer to themselves as manga artists. Anime correctly refers to animation created in Japan, though in the West, it is again used more loosely to mean a style and genre of animation that is derived from Japan. It often features detailed, colorful imagery, in-depth characters and action-orientated plot lines set in the past, present or future or frequently within a fantasy setting. The meaning of the term 'anime' can vary depending on the context it's used in.

So, to summarize, the terms manga and anime both mean artwork in a typical Japanese cartoon style; the difference is the format. Also, manga tends to be monochrome, while anime is often in full color.

MANGA DETAILS

The manga style has been gradually evolving over the last century, but in the 1960s–1980s it really seemed to commit to the visuals which many fans are familiar with to this day. These often include the following characteristics:

❱ **Large eyes (especially female and younger characters)**
❱ **Small noses, usually simplified as a dot or an L-shaped line**
❱ **Flat-looking faces and angular chins**
❱ **A wide range of hair and eye colors**
❱ **Overstated hairstyles**
❱ **Lean body types**
❱ **Exaggerated breast size**
❱ **Emotion indicators such as an oversized sweat drop or cruciform vein on the head**
❱ **Simplified linework**
❱ **Background effects such as speed lines or patterned tones**
❱ **Gray tones in manga**
❱ **Solid two- or three-tone 'cartoon' coloring styles in anime.**

I'll be using a range of different styles and themes to illustrate how to draw various manga creations. Over years of practice, I have developed my own way of doing things and this will undoubtedly be evident in the artworks here. If you want to experiment with adapting any of the characters to be, for example, even more cute and 'chibi', go for it! Or if you prefer dark and moody color schemes, don't feel you need to stick with the bright and colorful tones I use. Manga styles should be adapted for your own preferences.

YOUR MANGA ARTIST JOURNEY

Drawing is a skill that takes a lot of time to master. It's a never-ending process of development that can deliver a massive sense of achievement, fun and excitement but if you're not careful, can also wound your ego and make you feel defeated when things aren't going quite right. Remember that whether you're 13 or 30, you can already draw and the more you do it, the better you'll get. Before embarking on the tutorials that follow, how about assessing where you are right now? Design yourself a character – just make it up in your head then date your work. This is your starting point. After a few weeks or months of practice and working through the tutorials, try doing the same thing again and see how much you've improved. I always date my work, either on the paper itself or on a labeled folder on my computer.

Every few months, take out all your drawings and lay them out in sequence or post them on your wall. Notice where you've improved and see if you can identify parts of your drawing

which need more work or development. Try turning your drawing upside down or looking at it in a mirror – areas which aren't quite working will jump out at you. The idea is to be your own critic and at the same time be kind to yourself. Take pleasure in your achievements and if you feel you haven't progressed as much as you'd hoped, use that as an incentive to improve rather than beat yourself up about it.

If you're halfway through a drawing and feeling frustrated that it doesn't seem to be going well, don't give up and throw it in the bin. Take a break and come back to it later, or simply persevere through the negative self-criticism and realize it's only a sketch right now and not a work of art!

Set some drawing goals – things you'd like to draw which will serve as practice. This might be a series of sketches, some inked drawings or full-color artwork. Then arrange some time to complete them. Maybe tackle one task a day, or complete a full-color work each week?

Carry a sketchbook at all times and draw whenever you have a moment to yourself or inspiration hits you. Make use of tablet or phone apps too for drawing or painting. Keep your drawing and painting gear close to hand and easily accessible so you can start without obstacles – if you have only a short time to spare, having to spend part of it locating what you need is a considerable deterrent to starting at all.

Read manga, watch anime, play video games and generally immerse yourself in the things you love to fuel your passion while analyzing what you like and don't like about the artworks. Make notes and keep a record of your ideas. It's a good idea to join an art class so that you can draw or paint with other students, all learning from each other. Alternatively, enter the online realm to collaborate with others around the globe. Copy, trace, draw from photos and life – as long as you are drawing, you are improving. Of course, you should never try to pass off someone else's art or ideas as your own. This book will give you an initial grounding in developing a manga style and creating manga characters, with step-by-step diagrams taking you from basic stick figure proportions to fully detailed, colored character designs. Ultimately, I hope you'll be able to apply your developing skills to creating your own style of manga characters. Draw a lot, experiment widely and most importantly have fun!

Tools and Materials

You can start creating artwork with little more than a pencil, an eraser and some paper – either a sketchbook or loose sheets. As you increase your skills, you'll want to invest in less basic materials and tools to get the most out of your work. Along the road to your artistic goals, I recommend experimenting with different media to find what you like using and feel suits your style, be that colored pencils, paint, markers or one of the many digital software packages available. Have fun creating different effects using a range of tools and techniques and see what you can come up with. It's useful to discover the kinds of tools you don't like as well as the ones you love.

A well-arranged workspace is essential for producing your artwork. Some people are happy to draw in a sketchbook on their lap or on their tablet while waiting for the bus and that's fine, but reaching a good standard will take lot of practice, so you'll want somewhere you can work that is comfortable for hours at a time. An ergonomic chair is recommended for lengthy drawing sessions to reduce back problems and having your pens, pencils and other equipment close to hand makes the process as efficient as possible. A clean and tidy environment can help to put you in a better mindset for a creative drawing session, so avoid clutter. However, it's useful having reference books close to hand or access to images on your computer for those times when you need a little extra inspiration or guidance.

Natural light is best when you are working with color so that you can see a realistic range of hues, but a lamp and overhead lights will help to reduce eyestrain on dull days. You can buy daylight bulbs with a color temperature that most closely reproduces natural light.

Typically, modern manga artwork will start out as a pencil sketch which is later refined by using black ink pens, then color or tone is applied. I've created artwork using pencil, ink and digital color for many years, but now I increasingly use digital media to both draw and paint. Of course being able to draw with just a pencil and paper is an invaluable skill for any artist and knowledge of both digital and traditional artwork creation methods is a must before settling on your chosen media. The basic tools required to create awesome manga artwork are described in the following pages.

Basic Drawing Equipment

You'll probably have some of these tools around your home already. In their basic form, all of them are easily available from high-street stationery stores.

PENCILS

Everyone is familiar with typical HB grade pencils (commonly referred to as 'lead', though in fact the core is graphite). If you intend to shade your work, though, a variety of grades is a must. Most manufacturers provide a range from 6H (the hardest) to 6B (the softest), with HB in the middle. Like many comic-book artists, I tend to draw with a 2H grade as this allows me to keep my guidelines light, smooth and clean. If I want to define my lines I can then use either a darker B grade pencil or ink.

Pencil marks softer than 2B will smudge, so it's best to reserve the softer grades just for shadows and shading. Placing a tissue under your hand while you're drawing is a good way to prevent smudges, or you can use a smudge guard which covers the areas of your hand and fingers that rest against the paper.

I prefer a mechanical pencil to an ordinary wooden one. I don't have to spend time sharpening it, the tip stays at a constant thickness, and the Pentel brand I use allows for the eraser tips to be replaced when they are worn out.

Pencils are the standard medium used by manga artists for quick sketches, layouts or fully shaded illustrations, so practice drawing with them as much as you can.

A 'non-photo blue pencil' is excellent for preliminary sketches before refining them with graphite or ink as the blue won't be picked up by a photocopier and can be more easily deleted using editing software after being scanned. I may use other colors to sketch before committing to lines with a darker graphite pencil, especially if I want to avoid using an eraser. Yellow, light blue and light green work well for drawing preliminary guidelines and shapes, while a darker red or purple can be used to refine these lines. By pressing lightly with your colored pencil, you can create delicate or subtle color combinations, while pressing harder creates more vibrant, solid tones. Blending colors is simply a matter of adding a second color on top of the first. By gradually building up colors on top of each other you can create a variety of tones without the potential for mistakes that comes with using a pen.

Advantages

❱ You've used pencils before so it's a medium you'll already have experience with.
❱ If drawn lightly, pencil marks can be removed with a soft eraser or putty rubber so shapes can be redrawn until they look right.
❱ Colored pencils such as Prismacolor are relatively inexpensive and easy to use and blend.

Disadvantages

❱ Pressing too hard can leave marks on the paper that remain after any errors have been erased.
❱ Pencil gives an inconsistent line, depending on the pressure applied. This can make it tricky to maintain the shape and tone of a line, particularly when using soft-grade pencils.
❱ Colored pencils require time and perseverance to build up rich, solid colors.

TEMPLATES AND RULERS

For drawing circles, templates are preferable to compasses as the latter can leave marks or holes in the center of the circles. French curves are always handy for smooth, accurate linework, especially for mechanical objects. I often sketch in shapes using rough pencil lines, then use the curves to correct the shapes, pressing harder to commit the lines to paper.

A ruler or straight edge is essential for drawing anything mechanical, action lines, borders and buildings. Creating backgrounds – especially streets, cities and interiors – is all about using rulers for perspective drawing.

When you're using templates and rulers to ink your work, be careful not to slide them around on the page or you may smear an inked line. Either wait for each inked portion to dry or carefully lift the template or ruler and place it down before continuing. Use a tissue or rag to wipe down the edges occasionally to keep it clean.

ERASERS

A good eraser is essential as you'll do a lot of erasing, especially at first, and a bad eraser can do more harm than good by causing dark smearing. Find one that removes graphite pencil with ease. I use three: a small, thin one on the end of my mechanical pencil which gets into small spaces, a larger one for when I need to remove lots of lines in one hit and a putty rubber, or kneadable eraser.

A putty rubber is great for getting rid of smudges without leaving bits of eraser on your page and can be shaped to get into small areas. It can also be used to lightly 'wipe' over pencil art, effectively lightening parts of your drawing and allowing you to further refine your linework with less mess. Occasionally you might want to clean it. The best way to do this is to rub away the dirty edges on a clean sheet of paper.

If you're using soft pencils, be careful not to smudge your work when wiping away pieces of eraser left on the paper – and when you're erasing pencil lines after inking, take care to give the ink some time to dry first to avoid smudging wet lines.

SURFACES

Artists have their own preferences when it comes to paper. Traditionally, comic-book artists use sheets of Bristol board, though some opt for cartridge paper sketchbooks. I'm not a huge fan of the grainy texture of those sheets and prefer smooth printer paper to draw on.

Ink, Markers and Paint

Inking is the process of converting pencil work to a high-contrast black and white as seen in manga comics. Ballpoint or fine-line pens can be used to give a consistent line thickness and come in various widths for both bold and fine linework.

Variations in line weight and thickness aren't as common in manga as they are in Western comics, but it's still important to give your linework some depth, for example by using tapering lines or making background lines thinner. Brush pens or quill nib pens which can be dipped into black Indian ink work very well for this.

If you look closely at manga art, you'll notice that line weight and thickness often diminish towards the end of a line. Tapering lines towards the tips is achieved by applying less pressure towards the end of a stroke – an important technique to make your work look more fluid and professional.

Successful inking is a skilled process and requires a different technique to penciling. Practice by inking several sketches before applying ink to your finished pencil drawing, just to get used to the medium. If you're feeling confident enough, you can bypass the pencil stage entirely and go straight into using ink. Any mistakes can be deleted using white correction fluid.

Markers are used for adding color or tone to finished inked work. They dry slowly and bleed into each other, making it possible to create smooth color blends. You can buy double-ended ones with a chiseled tip for technical application and a thin tip for details. Brush tip markers are fantastic to work with, as they're like a paintbrush with a constant flow of color. I like to use a set of six gray brush markers in different tones to create monochromatic work with multiple layers of depth.

Advantages
❯ A simple ballpoint pen or biro is easy to use like a pencil.
❯ Inking makes your work look solid, bold and clear, ready to apply color or tone at a later stage.
❯ Markers are a quick and convenient solution for adding saturated color or tone without the need to mix paint or wash brushes.

Disadvantages
❯ Ink cannot be removed without spoiling your paper and drawing.
❯ Markers require thicker paper that will not wrinkle or allow inks and dyes to bleed through.

PAINTS

After penciling or inking your artwork, you can turn to painting as the final stage in bringing your finished work to life. With an illustrative style like manga, you will probably wish to use watercolor and acrylic as your media.

Watercolor painting provides subtle tones and delicate washes that will give your work a loose and fluid feel rather than the bold and graphic effect you get with markers. Watercolors suit a fine-art style of working as they are very organic in the way they are applied and appear on the paper – that is to say, there is potential for the paint to run, bleed and disperse across the canvas, compared to a more mechanically precise medium such as a pencil. To start with you'll just need a dozen or so colors, a few brushes of different sizes, water to dilute your paint and clean your brush, and a palette or white china saucer on which to mix your paints. You can paint direct onto canvas or watercolor paper. Make sure you use paper of a minimum weight of 300gsm (140lb) to avoid it cockling (developing an uneven surface) when wet.

The advantages of acrylic paints are that they are quick-drying, provide deep, solid colors and can be applied in opaque layers to build up colors, refine details or correct mistakes. A beginners' set of 10 or more tubes of color should be enough to get you started. As you develop your skills, you might like to experiment with different types of acrylic of varying consistencies. You'll also require water and a paper towel for cleaning, a palette to mix on and different-sized brushes. Once transferred from their container to a palette, acrylic paints dry very rapidly so you might like to buy a stay-wet palette to delay this.

Start painting with a large brush and work on bigger areas of color before focusing in on details with a smaller brush. Acrylic is quite a thick paint and can be watered down if needed to achieve thin washes or watercolor-like effects. It's very versatile and as long as you avoid oily or waxy surfaces, you can apply it to paper, canvas, glass, wood, metal or plastic.

Advantages
> **Paint offers more texture and natural fluidity than ink.**
> **It is more hands-on and tactile compared to using pencils, pens or a computer.**
> **Traditional media such as watercolor and acrylics create a tangible piece of artwork which has more value if you want to sell it.**

Disadvantages
> **Paint can be difficult to control and requires some experience before you can handle it well.**
> **It is messy, and requires additional time to set up and clean down.**
> **Mistakes are easier to make and much harder to correct than in digital media.**

Digital

Using computers to create artwork has taken off big time. You probably already own a laptop, desktop computer, tablet or smartphone and all these devices are capable of creating beautiful digital art with some practice and perseverance.

Typically, manga and comic artists will draw their characters or pages with pencil, ink them by hand, then scan them and complete the color stage using the computer and a graphics tablet. However, artists are increasingly moving towards wholly digital creation from start to finish. The industry standard graphics software is Adobe Photoshop. It's a versatile program for modern-day photographers and artists alike and I've been using it for my art and illustration projects for many years. PaintTool SAI, Manga Studio and Gimp are low-cost alternatives worth considering.

Advantages

❱ **You can launch straight into creating your artwork without spending time sharpening pencils or mixing paints.**

❱ **It's easy to edit out any mistakes.**

❱ **You can use different techniques to create artwork in a multitude of styles and mimic various traditional media without the variety of equipment you might otherwise need.**

Disadvantages

❱ **Learning new software can take time and you need patience to get to grips with it.**

❱ **If you don't already have the necessary hardware and software the initial outlay is very expensive compared to traditional media.**

❱ **Arriving at the final printed artwork isn't as tactile as traditional methods.**

Other Useful Tools

Manikins are useful for reference, although the anatomy of the old-fashioned wooden figures isn't particularly accurate. I prefer using action figures with many points of articulation, especially Japanese Material Force Micro Man toys, as they're great for drawing heroes who bend and pose more naturally. However, traditional wooden hands are a good reference.

Your smartphone or other camera is handy for taking pictures of yourself, your friends or various environments for future reference. All great artists have used visual references at one point or another to make their work more accurate and believable, so don't ever think of it as cheating.

A scalpel is useful for trimming paper. Traditionally, manga artists would use one to cut then apply screen tones (a textured or shaded film placed over artwork), though textures and tones are now more often added digitally.

A light box is great for tracing rough sketches onto a fresh new sheet of paper. When I'm tracing, I like to use a small piece of masking tape attached to the four corners of my paper to make sure it stays aligned. I also use masking tape to fix my sheets of paper in place on a drawing board or other hard flat surface.

12:45 PM

bcd

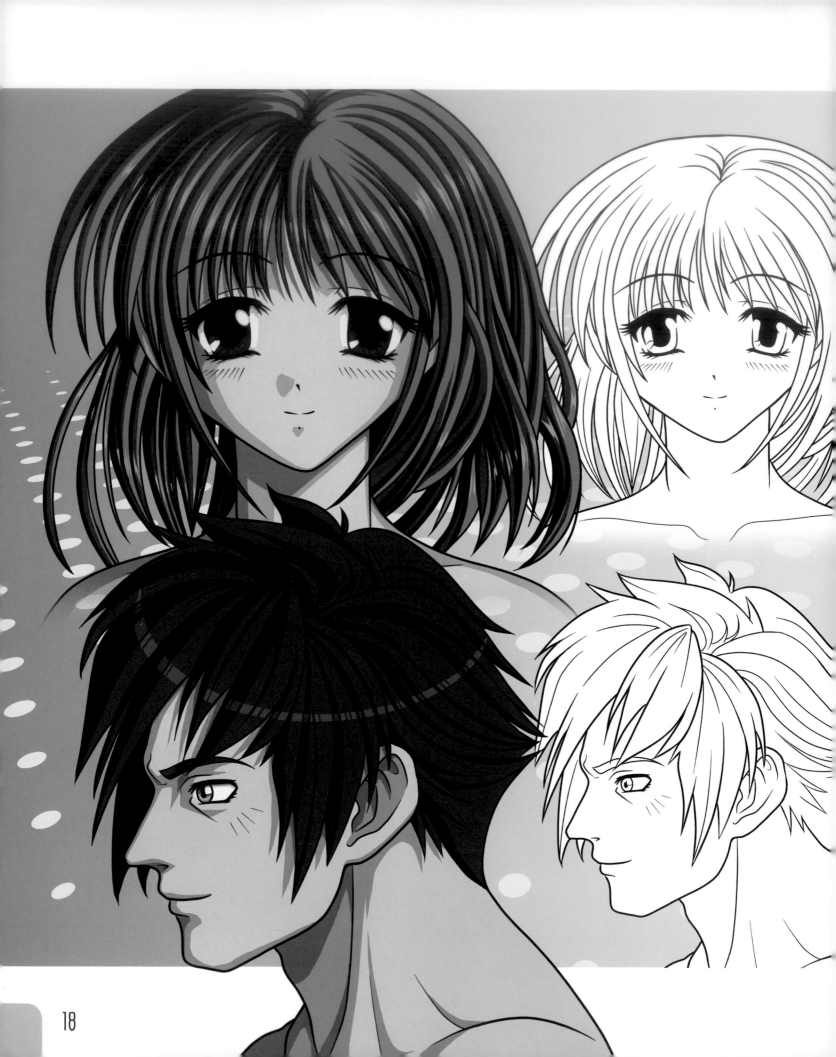

Heads

Drawing a head is pretty straightforward as it can be constructed using a circle for the top part and protruding lines for the jaw. Heads come in various shapes and sizes determined by the character's age, gender and physique or simply by the many different manga styles we can use.

The size of the head is arguably one of the most important parts of any character creation or figurative artwork as it will determine how much detail you can add to the face, how big the rest of the body must be and from there what size you should draw any other characters or environmental objects.

When I was at school my art teacher's advice was to start by drawing a person's eyes then build the rest of the face around them. While there's nothing wrong with that method per se, I always found myself drawing super-detailed eyes, then I'd move on to the rest of the face only to find that my sheet of paper wasn't quite big enough – so I'd have to erase everything I had done and start again. Now I always use a rough circle or oval to work out where on the page I'm going to start drawing a head and how big it should be. From this initial guide I can see how much room I have to play with and if I'm not happy with that it's very easy to erase the guide circle and draw one a little bigger or smaller depending on what's required.

This chapter shows step-by-step construction methods for front, three-quarter and side view heads, along with a selection of angled manga heads for reference.

Heads from Different Angles

If you're a beginner, I recommend you start drawing heads from a front view. This will allow you to work out general facial proportions such as the distance between the lips and chin, or the gap between the ears and eyes. Keep your initial head circle guidelines light so they can be erased easily and don't get in the way when you are marking the proportions of the face. Of course, people's features vary widely, and even more so in manga. Look at the examples on this page and consider how big a character's eye is, then use the eye as a reference point and a term of measurement. For example, a character's head might be the same width as four eyes in a line, or the distance from the top of the eye to the top of the head might be the same as the bottom of the eye to the bottom of the chin. Using a reference point and comparing is a much more accurate way of judging proportions than blindly guessing.

Once you feel comfortable with heads seen from the front, try them at an angle. Most artworks you create will illustrate characters facing towards the viewer and introducing angled heads can make a big difference; front views can look a little awkward or just less dynamic and the same can be said for the rest of a character's body. If I do draw a head at a straight-on view, I often angle the body a bit so the pose doesn't look so rigid.

Heads and faces are among the trickiest things to draw, since we are all familiar with what people look like and will immediately notice if a forehead is too wide or a chin is too long beyond the boundaries of stylistic freedom that manga can provide. They are also the most rewarding aspects of character creation. Artwork of, say, a finger is not particularly interesting, even if you draw all the subtle wrinkles, while a well-drawn head or bust (head and shoulders) can often look great as a stand-alone piece of artwork.

Here I've illustrated different styles to consider and angles which can be studied for reference.

《 If the head is tilting downward, the facial features move down, while the height of the ears moves up. More of the top of the head is shown.

》 Eyebrows are around the same height as the top of the ears.

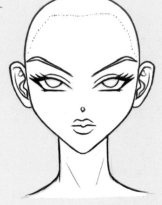

《 When the head is tilted up the facial features move up while the height of the ears moves down. More of the chin and the underside of it is visible.

》 The further the head turns to the left, the narrower the right eye will look, and vice versa.

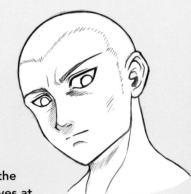

《 Notice the subtle curves at the side of the face – there's a slight indent next to the eye socket.

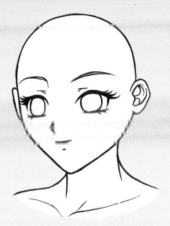

❰ The head may be made wider to accommodate bigger eyes.

❰ Characters won't often be bald, but it's always useful to know the shape of the top of the head so that hair can be added to the correct height and position.

❱ If tilting the head up in a ¾ view, facial features will need to be drawn at a diagonal angle.

❱ Exaggerate and play with certain facial features to create something scary!

❰ Larger heads in proportion to the body are more cute and childlike.

❰ Remember to use guidelines! Horizontal parallel lines will stop eyes and ears from being asymmetrical. These guides can be erased when you finalize the artwork.

❱ Manga ear size and shape are often similar to reality, although they may be enlarged and simplified.

❱ The rear of the head will be an identical shape to the front, with the obvious exception of facial features and a jawline and chin.

❰ Tilting a head downwards will mean the eyebrows will be closer to the eyes.

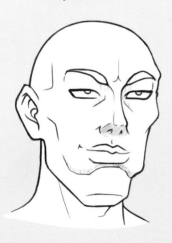

❰ Manga characters tend to have big eyes and small noses and mouths but this isn't always true, especially of male characters. Lumps, bumps and facial contours are more evident on older manga characters, villains and muscular types.

❱ Tilting a head upwards means the tip of the nose will be closer to the eyes.

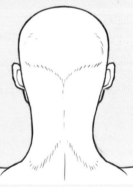

Constructing a Female Head: Front View

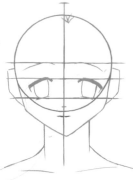

1 Start by drawing a faint circle. Add a vertical center guideline to help you draw symmetrical facial features. Carry the line down beyond the circle as an aid to measuring the width of the neck and shoulders later on. I'm using red in this example, but would usually make light pencil lines.

2 Draw in the jaw as vertical lines running down from the side of the circle then create a chin by drawing steeper diagonal lines until they meet in the center guideline. Manga faces are often quite pointy, but round off any angles slightly to reduce the look of sharp corners.

3 Add in some more faint guidelines to indicate where the eyes, top of the eyebrows, nose and mouth will be positioned. The bottom of the eyes will sit about halfway between the middle and bottom of the circle and the eyebrows around the middle of the circle. The top of the hair will protrude above the circle and the top of the ears will be near the eyebrow line.

4 Begin to define the facial features by refining the shape of the eyes, adding in the ears and using a single curved line for each eyebrow. The sides of the neck align with the middle of the eyes – use the center guideline to check that you are getting the placing of the neck lines equidistant. Use gentle, sloping curves to indicate the trapezius (shoulder/neck) muscles joining the shoulders. Very slight angled lines beneath the neck indicate the collarbones.

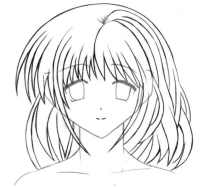

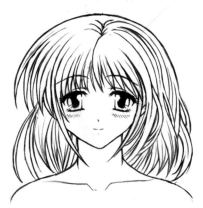

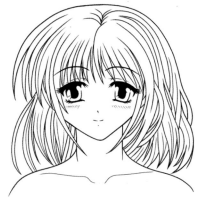

5 Erase the initial faint guidelines and then add the hair. Rather than draw individual lines, group it into a selection of long spikes or bangs. Try to keep these spikes roughly the same length for the fringe, then getting longer towards the side of the head. Taper each spike towards the bottom. The ears will be mostly covered with hair.

6 This step shows the final pencil drawing. You can see how I've continued to refine the drawing by adding in detail to the eyes, smaller strands of hair and some 'blushie' lines underneath each eye. At this stage, you might consider adding a little shading here or there to increase the detail. In this example the head will be inked and colored so this isn't necessary.

7 Clean up the drawing by inking over the top of it, either by tracing it on to a fresh sheet of paper and redrawing it with a pen or by scanning it and going over it using a graphics tablet and digital software.

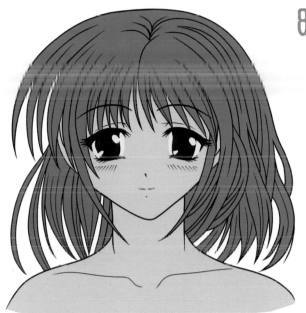

8 Next, choose your color scheme. The way you build up your colors will depend on which medium you choose to work with; if you're using paint or digital the first step is laying flat tones before shading. Alternatively, you might want to start with the lightest colors first before introducing increasingly darker shading and shadows as in steps 9 and 10. Within the anime genre, hair colors can hint at a character's personality rather than just being realistic – in this case I've gone for green, which, along with the cute big eyes, can mean she's a trustworthy, easy-going, kind-hearted character. (Green hair with a long face and narrow eyes might indicate a greedy, selfish character instead.)

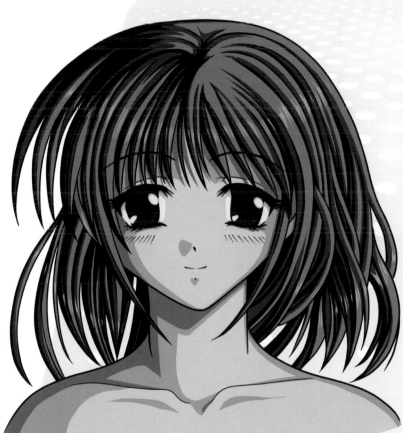

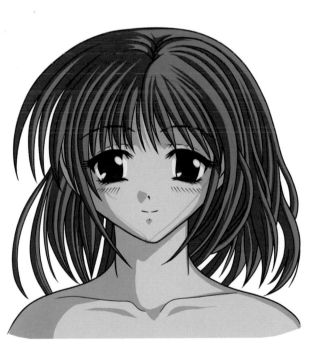

9 With a right-hand light source in mind, place shadows on the left-hand parts of the skin and hair using a darker tone. The head will cast a lot of shadow under the chin and on the neck. The cheeks, on the other hand, don't have a lot of shadow. Each spike of hair needs shading to give it a three-dimensional effect.

10 The final step is a second round of darker shading on the hair and skin to help add more depth to the features. I've given the hair additional highlights – two curved bands of lighter tones to give it a more glossy look. To finish, I put some extra-subtle shading and highlights in the eyes.

Constructing a Male Head:
Three-quarter View

1 Start by drawing a faint circle and add a curved guideline to indicate the center of the features. The head will be angled toward the right, so this line will be positioned at about a third of the way from the right. Indicate where the bottom of the chin will be.

2 Draw in the cheekbone as a diagonal line on the right and extend the sides of the face down to meet the chin line at the bottom. Add the jawline on the left as two diagonal lines as shown. The top jawline will bisect the circle guideline and the ear will be placed to the left of this line.

3 Add in some more faint guidelines to indicate where the eyes, top of the eyebrows, nose, mouth and ears will be positioned. The bottom of the eyes will be about halfway between the top of the head and bottom of the chin. Because of the angle of the head, the ear on the right will be out of view and facial features will be narrower than those on the left.

4 Begin to define the facial features by adding the nose off-center to the guideline, drawing in the eyes within the guideline boxes and adding the eyebrows and ear. Draw in the neck, consisting of a line coming down from the center of the chin and another from the middle of the ear. Also put in angled lines to indicate the trapezius (shoulder/neck) muscles sloping from the back of the neck. Add a few marks to indicate where the hair will start.

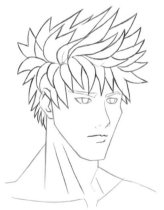

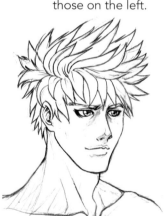

5 Erase the initial faint guidelines and then it's time to add the hair. Place thick triangular spikes of hair to soften the facial features, keeping them roughly the same length and considering the overall direction – in this case the hair is mostly pointing towards the top right. Next, define the ear with more detail. The lips are pretty simple, with the dividing middle line being the most prominent and a smaller line underneath to indicate the bottom lip. Add some slanted lines on the neck to show the tendons and indicate where the collarbone will be.

6 This step shows the final pencil drawing. You can see how I've continued to refine the drawing by adding detail to the eyes and smaller strands of hair and smoothing out some of the edges so it doesn't look too angular. If you don't intend to take the image to an inked or colored stage, you might consider adding some hatching (closely drawn parallel lines) and a little shading here or there as shown to increase the detail. In this example the head will be inked and colored so this isn't necessary.

7 Clean up the drawing by inking over it, either by tracing it on to a fresh sheet of paper and redrawing with a pen or scanning it and using a graphics tablet and digital software.

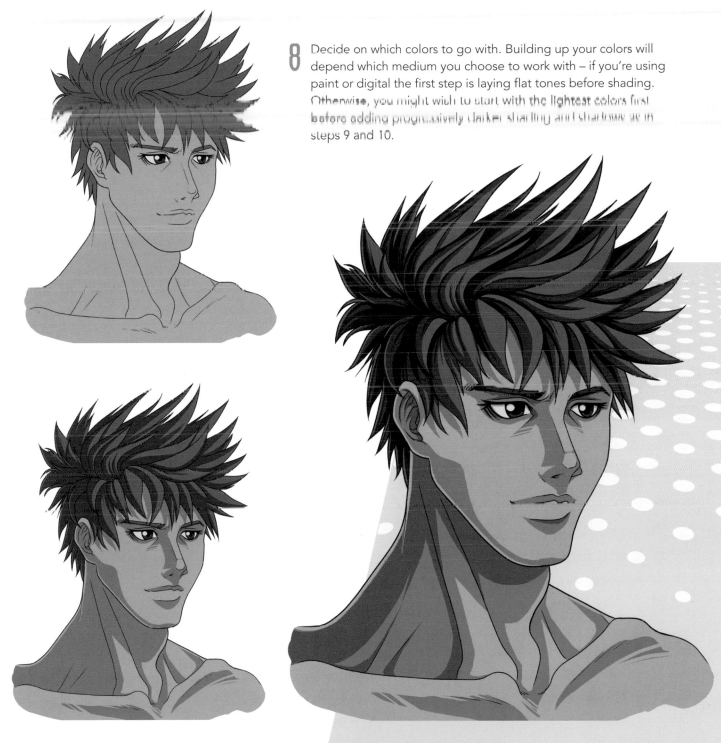

8 Decide on which colors to go with. Building up your colors will depend which medium you choose to work with – if you're using paint or digital the first step is laying flat tones before shading. Otherwise, you might wish to start with the lightest colors first before adding progressively darker shading and shadows as in steps 9 and 10.

9 With a right-hand light source in mind, place shadows on the left-hand parts of the skin and hair using a darker tone. The head will be casting a lot of shadow under the chin and on the neck, and there will be a lesser degree of shadow on the face, cast by the hair. Each spike of hair needs shading and the left side of the hair will be darker.

10 The final step is a second round of darker shading on the hair and skin to help add more shape and contour the features. Adding a third round of shading or additional highlights is an option but I don't feel it's always necessary. The eyes have also been given subtle shading and highlights.

Constructing a Male Head:
Side View

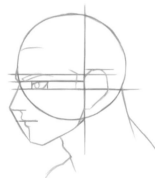

1 Start by drawing a faint circle with a pencil. The character will be facing towards the left, so pencil in an off-center 'crosshair' towards the bottom right as shown. These guidelines will be used to position the eye and ear.

2 Draw a box-like shape towards the bottom left. This will be used to house the nose, mouth and chin. The blue lines indicate the portions you want to keep – the top of the nose and the jaw.

3 Add in some more faint guidelines to indicate where the eyes, top of eyebrows, nose and mouth will be positioned. The bottom of the nose will roughly line up with the bottom of the ear. The top of the ear will be positioned a little higher than the eyebrow, and the eye will sit in the box towards the left.

4 With the guidelines in place, begin to create the facial features by refining the eye as an almond shape and forming the brow above. The tricky part in creating convincing side views is the contours between the nose and chin, so carefully study the subtle lines and bumps which make up this part of the face. Create the neck with lines stemming from halfway along the jaw and towards the back of the head. I've also added an indication of hairline, although I intend to give this guy big hair to cover it.

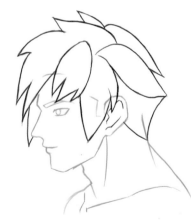

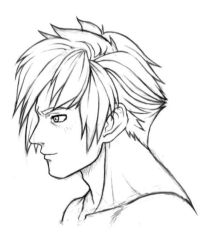

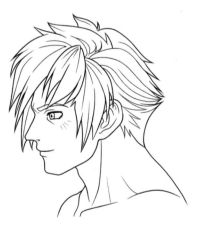

5 Erase the initial faint guidelines and then begin to add the hair, which is simplified by being sectioned off into large shapes. Each is strategically placed to overlap the face without obscuring the eye. Also add neck tendon and collarbone lines at this point.

6 This step shows the final pencil drawing. Continue to refine the drawing by dividing up the hair into smaller portions to help illustrate the hair flow and direction. The eye and ear have also been given more detail. At this stage, you might consider adding some hatching and a little shading here or there for effect if you do not intend to ink or color the image.

7 Ink the drawing, either by tracing it on to a fresh sheet of paper and redrawing with a pen or by scanning the drawing and going over it using a graphics tablet and digital software. In this example I have inked using the software PaintTool SAI.

8 How you build up your colors will depend on which medium you choose to work with – if you're using paint or digital the first step is laying flat tones before shading. Otherwise, you can start with the lightest colors first before adding progressively darker shading and shadows as in steps 9 and 10. I wanted my character to be the adventurous, leader type so I've gone for a strong shade of red for his hair.

9 With a right-hand light source in mind, place shadows on the left-hand parts of the skin and hair using a darker tone. The head will be casting a lot of shadow under the chin and on the neck and there is some more minor shading on the face. Each spike of hair needs shading, especially the left side of the hair which will be darker.

10 To finish, make a second round of darker shading on the hair and skin to help add more depth to the features and give some extra-subtle shading and highlights to the eyes.

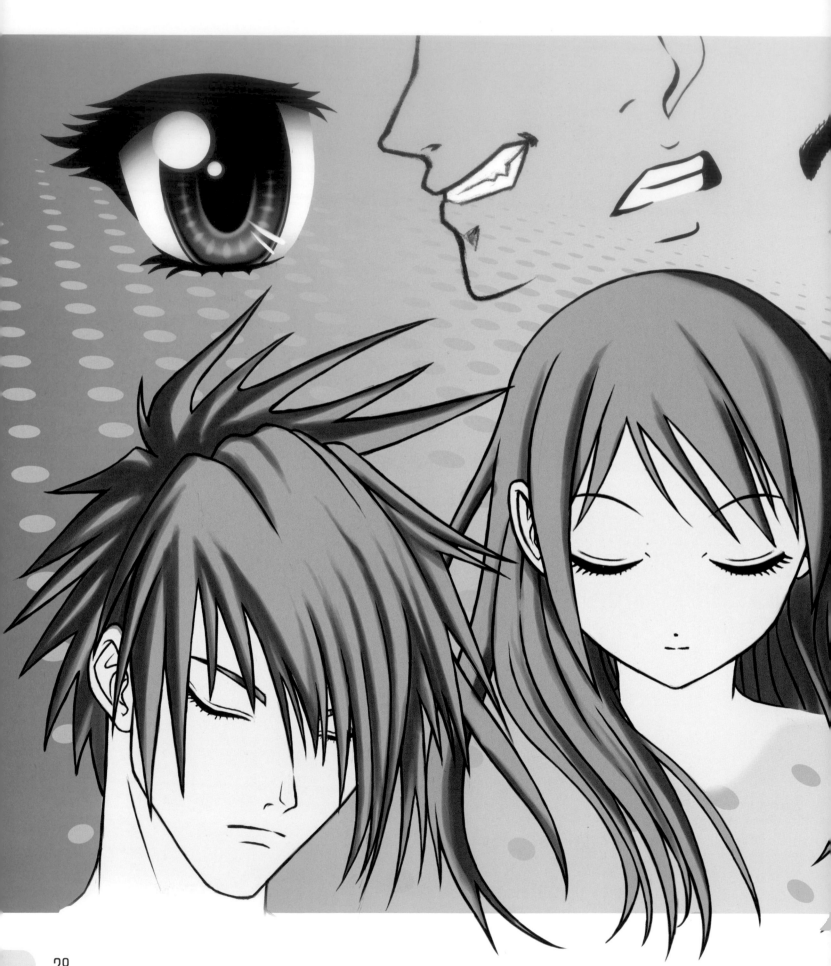

Faces

In real life, faces have a variety of shapes, sizes and characteristics and in manga these varieties can be exaggerated despite the simplified aesthetic. In the last chapter we looked at constructing a complete head and now we shall consider the individual features which go into creating distinctive personalities. By reproportioning facial features you can indicate whether a character is old, young, male, female, good or evil.

Over recent years, more and more people have become familiar with the huge array of styles within the manga genre. Fans appreciate that the fantastically popular *Pokemon* and *Dragon Ball Z* are just two examples of a vast and varied output. Even so, there are many shared themes, traits and considerations which make manga distinguishable from comics and cartoon styles produced in the West. Manga is more of a graphic illustrative style; it doesn't often use a lot of linework and heavily shadowed areas like a typical Marvel comic, instead stylizing faces with simplified, neat and elegant lines. If need be, the style and shape of the face will allow for a wide range of exaggerated expressions to convey a character's mood. Large, round eyes or simple noses and mouths represented with just a few dashes or curves may sound easy to draw, but there are still right and wrong ways to show the features which are outlined in this section.

Eyes

Manga faces revolve around the eyes. They're the key component to give your characters emotion, personality and a unique style. They're lots of fun to practice and experiment with but can be tricky to get right as they need to be balanced, symmetrical and placed correctly. They're usually positioned halfway down the head and spaced one eye's width apart. If the eyes are quite large, you'll need to draw the head a little wider to accommodate them.

How detailed you choose to make your characters' eyes is a matter of personal taste. Since there's not a lot of focus on manga characters' noses and mouths some artists like putting a lot of details, colors, lighting effects and flares in or around the eye to create a focal point on the face. However, they are always simplified to some degree since such characters would probably need to be redrawn a number of times as part of a comic or animation.

While large saucer eyes are a common trait in manga, eyes can come in a variety of shapes and sizes which still adhere to a manga aesthetic. I've drawn some examples here to give you ideas and some reference to use.

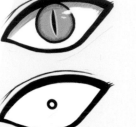

❮ Adjusting the iris, pupil and color schemes can create villains and demons.

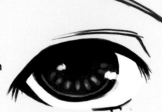

❮ The shiny look is achieved by using a ball of light reflection which contrasts against the pupil and iris.

❯ The eyelid covers the top of the iris unless the eyes are wide open with surprise.

❮ Villains tend to have small dot-like pupils. This can also be used to denote shock and surprise.

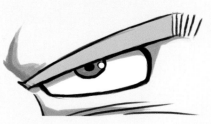

❯ Tilt the eyebrow down toward the nose to create angry, confident characters or tilt the opposite side to create a worried or submissive look.

❮ Closed eyes means the top lash is lowered to meet the bottom.

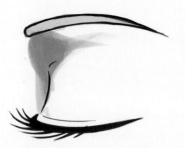

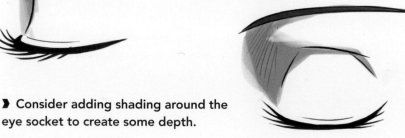

❯ Consider adding shading around the eye socket to create some depth.

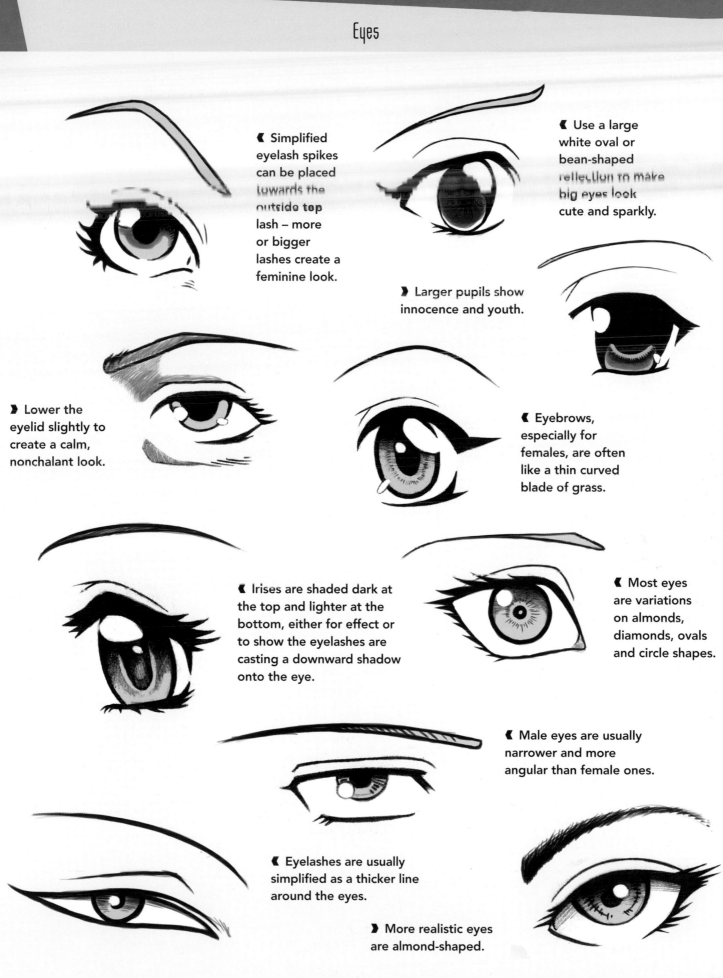

《 Simplified eyelash spikes can be placed towards the outside top lash – more or bigger lashes create a feminine look.

《 Use a large white oval or bean-shaped reflection to make big eyes look cute and sparkly.

》 Larger pupils show innocence and youth.

》 Lower the eyelid slightly to create a calm, nonchalant look.

《 Eyebrows, especially for females, are often like a thin curved blade of grass.

《 Irises are shaded dark at the top and lighter at the bottom, either for effect or to show the eyelashes are casting a downward shadow onto the eye.

《 Most eyes are variations on almonds, diamonds, ovals and circle shapes.

《 Male eyes are usually narrower and more angular than female ones.

《 Eyelashes are usually simplified as a thicker line around the eyes.

》 More realistic eyes are almond-shaped.

Constructing the Eyes

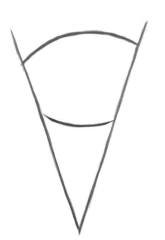

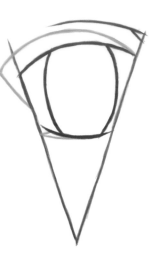

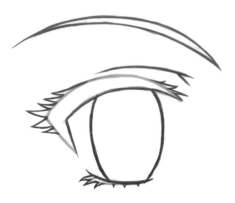

1 Starting with the left eye, lightly draw V-shaped guidelines. This will help to indicate how much longer the top eyeline needs to be in relation to the bottom. Inside these lines, place two opposing curves for the top and bottom of the eye, with the top line ending a tiny bit lower towards the left.

2 Place an oval shape inside the curved lines, cutting off both the top and bottom parts of the oval. Draw a shorter curve parallel with the top curve to indicate the eyelid. The right side of this curve will end with a 'y' shape. Next lightly draw in where the eyelashes will be – indicated in blue.

3 Give the eyelashes some detail. I usually draw 3–6 spikes coming off the outer side of the eye – they are always bigger than the inner side of the eye, which will usually just have 1–3 thinner spikes. Draw the eyebrow line above. As this is a female eye, a central, thin 'blade of grass' is sufficient. I've indicated where the pupil will be, also in blue.

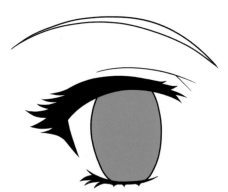

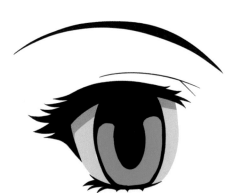

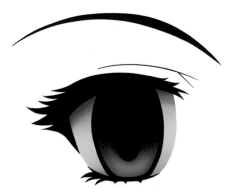

4 Next, tidy everything up. In this case I've inked over the top to make the lines a little smoother. Now it's time to consider colors – the fun part! Pick a base color. I've gone for blue in this example.

5 Fill the pupil and add shadow to the top portion of the iris and around the outer edge as shown. Use an off-white tone to color the eye white: solid white can be too overpowering so give it a hint of blue, purple or gray. Cast a little shadow at the top of the eye white. Next, fill in the eyebrow with an appropriate color.

6 Begin to blend in the darker tones. Try to create a graduation effect with the iris, from black at the top into blue, with the lightest color towards the middle-bottom.

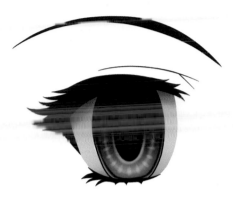 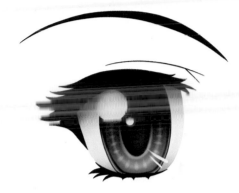

7 Put highlights in the iris to create a luminous effect: add a thin lighter tone to the outside iris edge as well as around the pupil, then add lighter lines in the middle between the iris edge and pupil.

8 To make the eyes look more glossy, add in some round highlights. These can be solid white or contain a hint of shading towards the top as shown. One big circle toward the corner, a smaller circle diagonally beneath and one or two stretched-out lines in the opposing corner are sufficient.

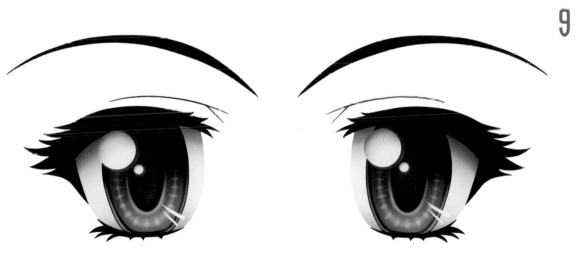

9 Now it's time to draw the other eye. Of course, in the process of drawing a character, you would draw and then color both eyes at the same time. Since a left-hand light source is generating the round highlights, remember to add a left highlight to the left side of the other eye. If you're using digital media, a simple copy, paste and flip won't do!

10 By tilting the eyes or coloring them green instead of blue it's possible to create a more confident, headstrong character. Or perhaps she's now just green with envy?

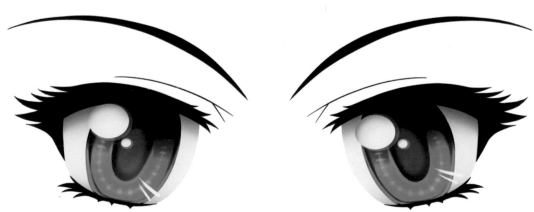

Noses, Mouths and Ears

While there often isn't as much emphasis placed on the noses, mouths and ears as there is on eyes in manga, they are still key components that need to be carefully considered. There is an art to making a few simple mouth lines look as if they belong. A triangular piece of shading may be all that's required to indicate a nose, but the distance between it and the mouth, or other parts of the face, will determine if a character has convincing proportions, or simply looks odd!

Forward-facing views in particular allow artists to use minimal lines or shading to show a nose and mouth. Within the many sub-styles of manga there is sometimes a need to be a little more detailed and realistic. Either way, a minimalistic approach is generally required and lots of lines or shading where a realistic face would usually contort with a smile or a frown aren't needed unless drawing older, aged characters.

I've included a number of examples to give some ideas on style and how things are simplified to create a manga look:

❰ Noses in a profile view can be drawn as a sharp and pointy triangle or a subtle, rounded contour. Mouth lines do not always reach the edge of the profile.

❰ Side or three-quarter views sometimes show a fang tooth to display mischievous intent.

❰ The angle of the face determines how much you see of the top or bottom teeth.

❰ Side-view noses can be rounded or impossibly pointy.

❰ Many of the examples here could be used for either gender.

❰ Simplify teeth with open mouths.

❱ Full, plump lips are only used very occasionally.

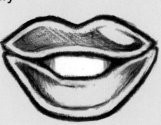

❰ Males tend to have longer, more angular noses.

❱ If the face is tilted backwards so the viewer is looking up at the nose, use short lines rather than large holes for nostrils.

❰ The mouth may get a little wider with a smile or when open, but the top lip stays in a fixed position and it's the bottom lip that moves down.

❰ Manga mouths are often quite small unless open, especially for females and children.

❱ Closed mouths can be drawn as a simple line or have a small gap in the middle.

❱ Noses and ears will stay the same shape no matter the facial expression used.

❱ Female characters will tend to have smaller, less defined noses.

❰ Learn how to draw ears for those characters that don't have them covered with hair.

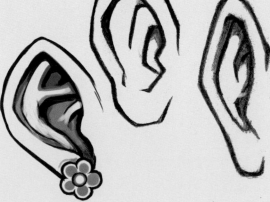

❰ Top lips are often left out unless the drawing is in a more realistic style.

Expressions and Emotions

By altering facial elements you can create emotion, indicate feeling or help to tell a story. Manga has developed its own unique visual language which conveys a plethora of emotional states. This manga iconography is often expressed with simple, exaggerated features and used to create some comic relief and light-heartedness within a story. While the more comical and over-the-top expressions don't appear in all manga, they are seen in many popular stories such as *Full Metal Alchemist*, *Azumanga Daioh* and *One Piece*. As a result of the ever-increasing popularity of manga, Western animation and comics have recently started to adopt the same Japanese emotional indicators. Here I've drawn a selection of expressions found in manga. I'm sure fans will recognize most of these.

FURIOUS
Adding in some oversized spider-man eyes and a comical monster mouth shows this guy is really mad. Add a popping vein in the form of a simplified cruciform shape to the top side of the head to show extra anger!

INDIFFERENT
These two faces show a generic content expression for when you want to show your character at ease and comfortable. I'll be using these two as a base to illustrate how tweaking just the facial features can indicate a range of emotion.

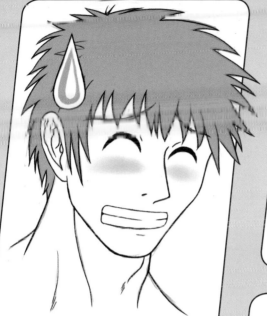

SHOCKED

When a character is surprised, enlarge the eyes but make the irises and pupils mere dots. Add shadow or vertical lines under or between the eyes to add a degree of anxiety and a greater sense of disbelief.

EMBARRASSED

The awkward feeling when you've turned up to school or work in just your underwear without realizing. Use 'happy' eyes, invert the eyebrows, and add the all-important oversized sweat drop to complete the look.

FRUSTRATED

This is typically indicated by drawing the eyes as inward-facing Vs. The oversized box mouth shows he's yelling. This is what happens to you when you don't save your work on the computer and have a power cut! It can also be used to indicate pain, as if he's just had a car run over his toe!

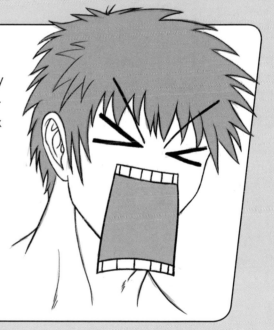

HAPPY

If your character is pleased with himself or herself, draw the eyes as upward-facing curves. Some characters will almost constantly show this expression if they are very welcoming, amenable and good-natured. Don't forget an upward curve on the mouth also. Adding faint hatching lines or pink or red 'blushies' to the cheeks will make him look tipsy or drunk.

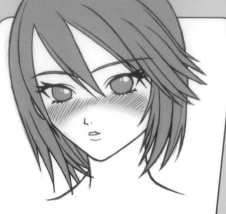

LOVING

This can be for another person or a thing. Perhaps a chocolate ice cream? This is a case of using hearts as eyes and placing several hearts above the character's head. Adding a long, open 'cat mouth' adds an added gasp of excitement.

ROMANTIC

Adding hatching lines to the cheeks or rosy-red coloring shows the character has feelings towards someone or is romantically embarrassed. This can be drawn as two separate 'blushies' or extend the width of the face as shown.

SLEEPING

Obviously you'll need to draw the eyes closed. The mouth is open with a half circle at the bottom to represent sleep dribble. As with Western comics, adding Zs above the head is optional. In manga, an inflated 'snot balloon' can show inappropriate sleeping such as during classes or at work.

CONFUSED

This can be indicated simply by tilting one eyebrow more than the other. To emphasize the emotion and create a more comedic tone, add round circles for eyes and a question mark at the top corner of the head.

SIGHING

Invert the eyebrows and draw the eyes as a single curved line to show they're closed. Add a mushroom shape coming from the mouth to symbolize the out breath of air when sighing.

EVIL INTENT

For those times when your character is being psychotic, mischievous, ominous and scary, darken the top portion of the face with shadow, hatching or a blue tone. Use the same circle eyes as before to help indicate it's a jokey, exaggerated expression, along with a monstrous grin.

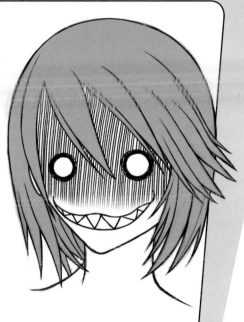

OTHER THINGS TO LOOK OUT FOR IN MANGA

» Lowering the head or hunching the body can show sorrow and dejection.

» A blue tone around a character's forehead or eyes can show gloominess or disgust.

» Flower backgrounds, cherry blossom or rose petals in the foreground can represent romance or a beautiful moment.

» A wavy ghost coming from the mouth can comically represent horror, depression, shame or extreme embarrassment.

» Lighting spark backgrounds can show a character has thought up a great idea.

» Simplified facial features and an absent nose can indicate astonishment.

» Falling to the floor, often with one or more extremities twisted above the body, is used to humorously indicate something ironic or unexpected being said, or suddenly happening.

» An exaggerated round swelling the size of an apple indicates injury.

» Twitching eyebrows or eyelids can show a character suppressing anger or frustration.

» A bleeding nose shows a male character's infatuation with or sexual attraction towards a female. Sometimes male characters' nostrils are enlarged.

» Spirals for eyes can show confusion or dizziness.

» Drawing 'chibi' (child-like) or deformed (big head, small body) versions of the characters indicates humor.

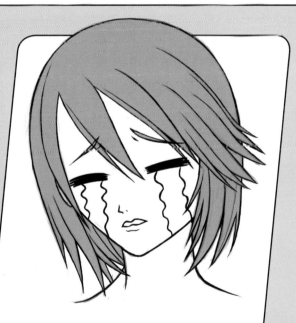

CRYING

You can illustrate this with either a single tear shown by a round blob on each outer corner of the eye, or for a more humorous 'waterfall of tears', add two wavy lines as shown. Invert the eyebrows to add some sorrow to the face.

39

Hair

Hair can be relatively easy to draw or complex, depending on your art style and how much you choose to simplify it in any particular drawing. As with eyes, manga likes to make a big deal out of the hair with female styles and long hair in particular is very intricate with many flowing, overlapping strands, bangs and clumps. The trick is to break down the hair into sections so that you don't feel overwhelmed.

Look in hairdressing or fashion magazines and websites for both conventional and outrageous reference material and practice as many different hairstyles as you can. There are several go-to styles you'll keep coming back to again and again – and you'll find tapered spikes, especially when drawing fringes or hair in front of the character's face, are favored by many manga artists.

❰ Give hair some flow to make it look more dynamic and direct it towards one side of the face.

❱ Pigtails and bunches are popular styles for younger female manga characters. A spiky fringe overlapping the eyebrows is something you'll no doubt draw often as it's commonly used and fairly straightforward to learn.

❰ More complex hair styles can take some practice to get right. Start with the largest sections of hair first before adding the smaller, narrow sections.

❱ Hairstyles that flare out don't necessarily need a lot of detail to create interesting shapes.

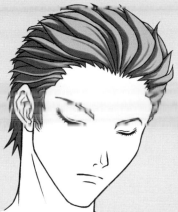

《 Short, slicked-back hair can sometimes represent educated, rich or classy types.

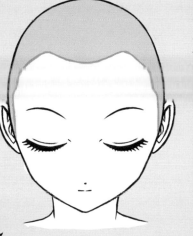

《 Keep in mind where the hairlines of your characters are. Once you've established the hairline, make sure hair flows out from behind it. Hairlines are more of a subtle 'M' shape rather than a straight horizontal. Keep in mind the hairline will be placed lower if the head is looking down and higher if looking up.

》 Large tapered clumps and spikes can be strategically placed so that they do not cover the eyes.

》 Messy or unkempt hairstyles can look fashionable. Or perhaps the character has just got caught in a shower?

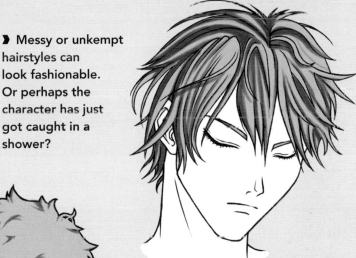

》 Short hair can be used for tomboy female cast members. The outline can be quite fine and detailed, while leaving the inner parts of the hair plain or using basic shadows to help add depth.

》 If you are creating a cast of characters, having at least one male with long hair will help add some diversity to the line-up.

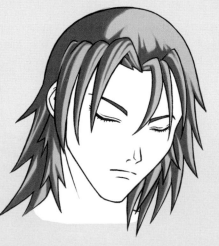

》 Gravity-defying hairstyles aren't unusual in manga. Add a floppy fringe at the front with wild spikes at the back.

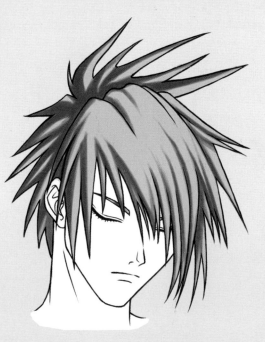

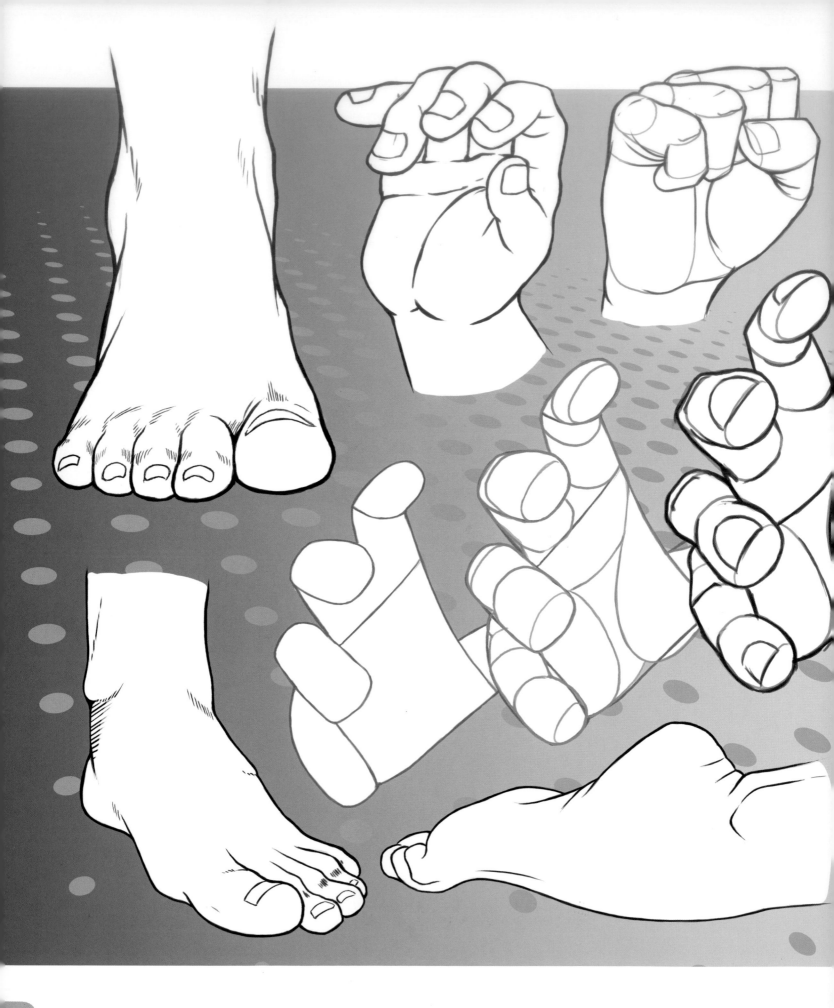

Hands and Feet

Hands are very important in expressing a character's intentions or simply making an image look more interesting. In Japan it's common to include at least one hand gesture in a portrait shot – this can be seen in public photos, selfies and magazine covers as well as manga and anime artwork. The two-finger 'V' or 'peace' sign is commonly used to help express happiness or make a person look more lively.

Drawing hands and feet may seem daunting at first; each finger or toe must be correctly proportioned on the hand or foot and you'll need to gain an understanding of how each of the joints articulate. It can be difficult trying to draw such small digits in relation to the rest of the body, since unless you're drawing on a large sheet of paper, a hand may need to fit in the space of a small coin and this can be quite fiddly work. Beginners sometimes resort to hiding the hands behind the back or putting them in pockets. There's nothing wrong with that if you're coming to this book with little experience of drawing character artwork and just want to focus on body proportioning. However, it will help if you can get into the habit of drawing hands and feet on your characters sooner rather than later. It you can get them right it will instantly make your artwork look more competent and appealing.

To start with, draw big. Use a full sheet of paper and try breaking down the hands and feet into more manageable parts. Practice drawing interconnecting cylinders from different angles to help you understand the many forms and perspectives that can be generated with the fingers in different positions. Do some life drawing of your non-drawing hand or use a photo of your hands or feet at different angles.

Hands

Manga hands can come in a range of different shapes and sizes, although unlike faces, they often aren't too far removed from realistic proportions. Drawing hands is more an exercise of simplification and knowing where to leave out the details. Whether or not you draw the many wrinkles, creases and skin folds you find on a real-life hand is up to you and depends on the style you're going for. Here's a range of hand positions and gestures to show a variety of angles you might use on your character work.

❰ Try pairing the fingers together to make hands look more lively.

❰ The lines on the palms show where the hands bend.

❰ A good tip is to start drawing the outer fingers – the index and pinky – before drawing the other two.

❰ Hands can look more dynamic if the fingers are pointing towards the viewer. The perspective created is called foreshortening.

❱ Fingers fan out rather than being parallel with each other.

❱ Drawing the nails is not always necessary. Sometimes they can be omitted or you can use a few lines towards the fingertips to give suggestions of a nail.

❰ Don't just add lines and folds for the sake of it – understand where they should be placed by studying photos and considering where the joints are.

❱ Female nails are usually more rounded or almond-shaped while males' are square-shaped, unless they are a demon!

❱ Female fingers will usually be longer and more delicate, while male fingers are thicker, especially in older individuals.

❰ Some hands will be drawn as simple outlines only. Fold lines, hatching, fingernails and creases aren't necessary if you'll be shading or coloring later on.

❰ Create a sense of depth by angling hands so that the fingers overlap each other.

45

Constructing Hands

1 To construct a dynamic open hand, start by drawing in the basic shapes to know how big the hand will be on the paper. Think of the hand as a square, with the two bottom fingers overlapping and the index finger extended. The hand should look as though it's coming toward the viewer, making the fingers appear shorter.

2 Using the initial lines as a base, flesh out the fingers to get more of a sense of form and volume. Keep things simple and think of it more like a robot hand at this stage as this will help you to understand angles and where the fingers and hand will bend.

3 Erase the initial guidelines, then over the blue guidelines begin to select which lines will be used to make the hand look more realistic, while adding in each nail to the fingertips.

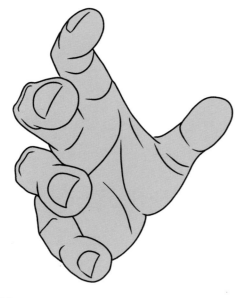

4 Next, erase any initial guidelines and clean up the sketch. In this example I've inked the outline to make it look crisp and smooth, then blocked in some color.

5 Sticking with a manga style, begin blocking in shadows to create depth. I used a left-hand light source, making the tops of the fingers lighter, and darker underneath. The entire underside could be completely shadowed, but I kept a few lighter parts on the palm to stop the hand from looking very two-dimensional.

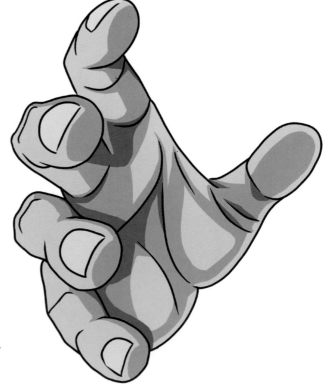

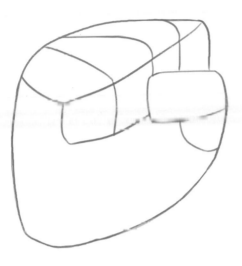 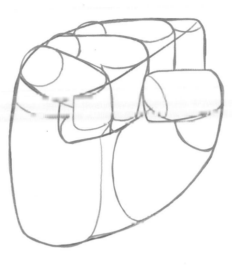 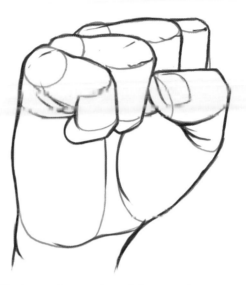

1 Constructing a fist is like sculpting the fingers out of a cube. Start with a light initial guideline to figure out the shape of the hand and the finger placement. From this angle, each finger will be overlapping the next with the thumb overlapping the index and middle finger.

2 Refine the guidelines and create more readable, three-dimensional shapes. As with the open hand, consider it a robot hand to help work out where each part of the hand moves and bends.

3 Erase the initial guidelines and begin adding in details and subtle curves to help make the hand look a little more organic. A realistic hand develops many creases when scrunched up like this, but be selective about where to put creases in order to create a simplified manga look.

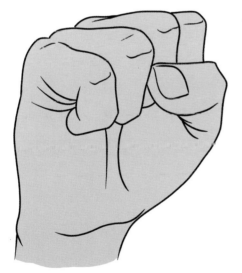

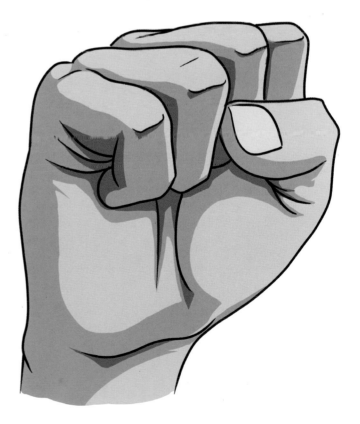

5 With a top-right light source in mind, add shadow to the left and bottom parts of the hand, with a few darker spots for added depth. This makes it look as though light is hitting just the tops of the fingers and palm and really helps create a more three-dimensional hand.

4 Take out any unnecessary guidelines and ink over the lines to make the drawing look neat and polished. You might consider retracing the image if it gets very crowded and dirty with the initial construction lines. Then add the skin color.

Feet

Drawing feet in a manga style is much the same as drawing hands. In terms of proportion, the length and width of the feet and the size of the toes will stay true to real life. Feet are a little easier to draw than hands since the toes are shorter and generally static if the individual is standing or sitting. The tricky part is understanding the contrast between a side and front view; the side shows the full length of the feet, tapering in towards the toes, while the front view looks compacted and spreads out towards the toes. Most of the characters you draw will be wearing shoes. These will follow the natural shape of the foot unless they have high heels, which will arch the foot.

❮ If drawing a posed character front view, you'll see more of the top of the foot.

❯ In three-quarter views feet are often pointing diagonally down, unless they are drawn from the rear in which case they appear to point diagonally up.

❮ Notice the subtle curves of the foot when it is laid out straight while an individual is kneeling or lying down.

❮ The ankle bone on the inside is always a little higher than the outer ankle bone.

❯ Feet will mostly move up and down from the ankle and have only a very small range of motion left and right.

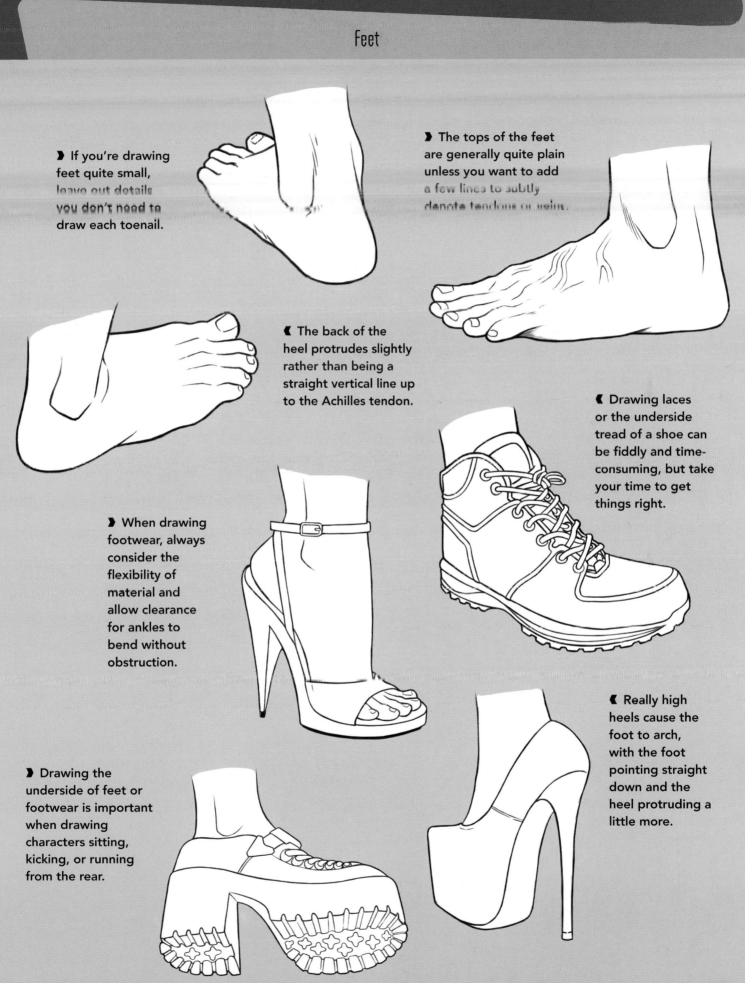

❱ If you're drawing feet quite small, leave out details you don't need to draw each toenail.

❱ The tops of the feet are generally quite plain unless you want to add a few lines to subtly denote tendons or veins.

❰ The back of the heel protrudes slightly rather than being a straight vertical line up to the Achilles tendon.

❰ Drawing laces or the underside tread of a shoe can be fiddly and time-consuming, but take your time to get things right.

❱ When drawing footwear, always consider the flexibility of material and allow clearance for ankles to bend without obstruction.

❱ Drawing the underside of feet or footwear is important when drawing characters sitting, kicking, or running from the rear.

❰ Really high heels cause the foot to arch, with the foot pointing straight down and the heel protruding a little more.

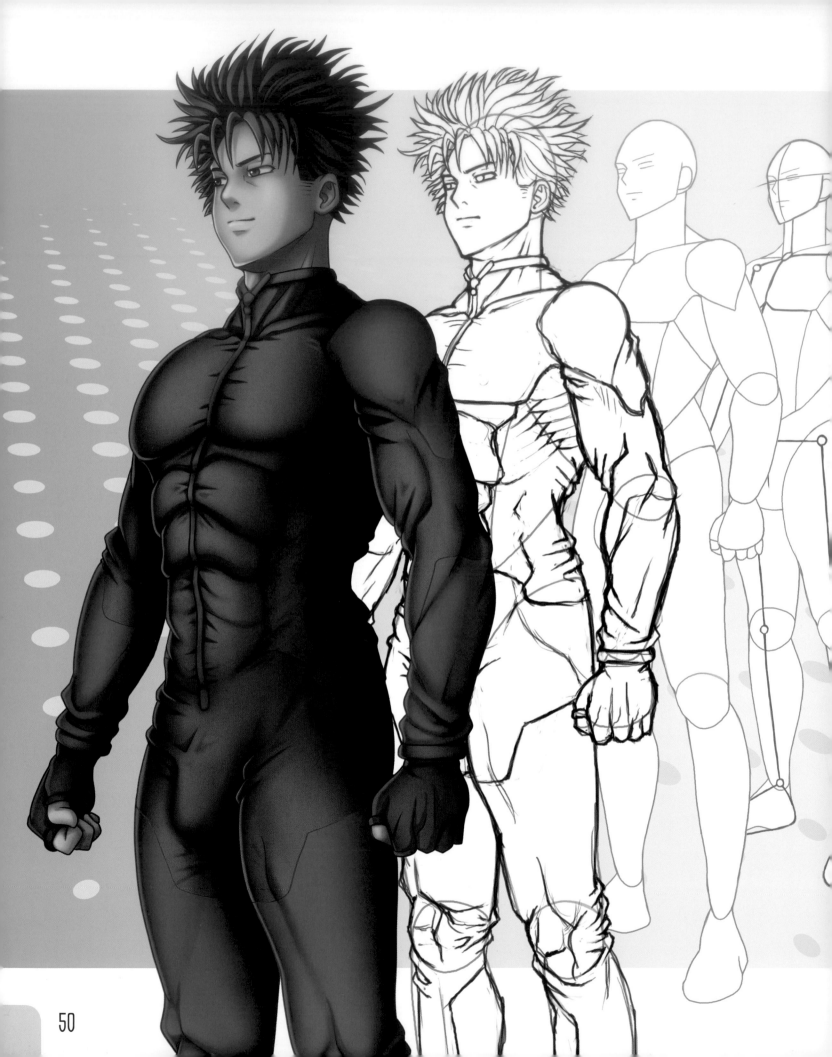

Figures

With the most expressive and intricate parts of the body covered in the chapters on the head, face and hands, it's time to gain an understanding of the anatomy of the whole figure so that you can move on to a complete character portrayal. That means familiarizing yourself with the overall proportions and the bone and muscle structure so that you can make your characters look believable. Drawing an unclothed model is the ideal, but if this isn't possible, just look at your own body in the mirror. You can try studying just one body part at a time – the leg, the arm or the torso, for example – to make things easier at first, but to understand how each body part connects to the next you'll need to start drawing full head-to-toe figures.

The body is important for defining a character's appearance in terms of size, weight and muscle structure. Most characters in manga are on the lean side as they tend to be young adults or teenagers; the majority of manga is marketed towards that age range and the fans want to follow characters they can identify with. Of course you don't have to stick with conventions – you can make your own creative decisions.

As with facial expressions, consider what the character's pose says about their personality. Open gestures and wide stances often suggest a confident, adventurous type, while a bent head with the shoulders slumped and arms tucked in will show the opposite. Once you feel confident with standing poses, try drawing people sitting, kneeling or in motion to give your work a little more variety.

To begin with, front views should be easiest and they'll help you learn the lengths of the limbs and body parts in a natural standing position. Three-quarter views will make your character look more interesting, however, and don't neglect rear views, which are especially important when figuring out clothes designs and how they will look from multiple angles. In this chapter, though, I'm keeping the clothing pretty simple and figure-hugging to help better illustrate the body shapes.

Experienced artists might choose to launch straight into a more finalized draft, or jump from the initial stick phase to a fully fleshed-out character drawing. Whatever you feel most comfortable with is usually the best route to take. When adding clothing there is always the sneaky option of adding material over parts of the character you find difficult to draw. Toes too fiddly? Cover them with footwear. Can't get knees right? Give her a skirt or dress!

Basic Shapes and Proportions

A human figure can be constructed using a series of shapes: squares, circles and triangles, or to make things more three-dimensional, cuboids, cylinders, spheres and cones. Even if you have only 30 seconds to practice your artwork, draw these shapes – especially cylinders at different angles – to help you later on when you convert these into more complex forms.

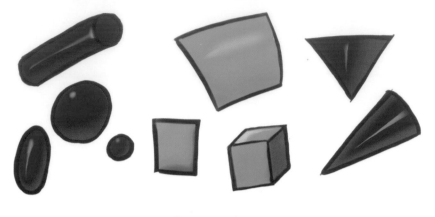

If you ever get stuck with your figure drawing, there's a limitless supply of reference: manikins (see p.17), photos of friends or selfies, magazines, books and online image libraries.

THE HEAD COUNT

An average fully grown male will be around 7–8 heads tall. So work out how big you've drawn the head, multiply that length by about seven, then you'll know where the bottom of the feet need to be placed. Some manga styles may exaggerate the length of the legs, making the character nine heads tall, while a younger character such as a 10-year-old may be five or six heads tall. Manga females are typically shorter than males of the same age by one or half a head. I've listed average manga proportions opposite. Use these as a guide, although of course keep in mind differences between character types such as young characters being shorter with larger heads, males potentially having wider chests and females having slimmer waists and larger hips.

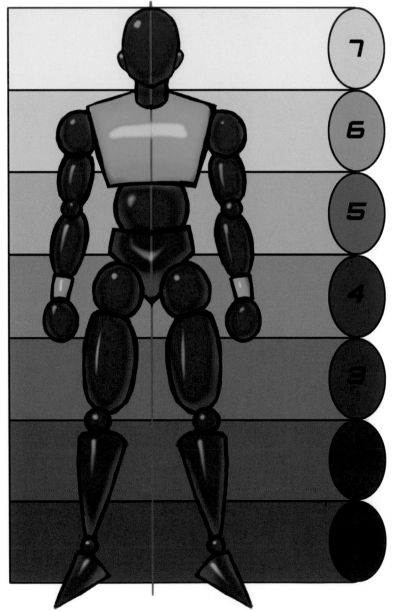

BODY HEIGHT
This is 6–8 head lengths high.

CHEST
The distance between the armpits is usually one head-length across, although male chests can be wider. In a woman, the nipples are one head height below the chin. Breast sizes vary a lot in manga, although they are typically the same width as, if not a little wider than, the width of the chest.

NECK
The neck is between one-third and half the width of the head. This varies a lot depending on the character's build, gender and age.

SHOULDERS
At two head widths wide, the shoulders are the broadest part of the figure.

WAIST AND HIPS
The waist falls slightly below elbow height. The width varies, but is slightly less than the width of the chest. The hips are twice the width of the head.

ARM AND HAND
The arm is the same length as the top of the knee to the toe. The fingertips end halfway down the thigh. The upper arm is about the same width as the neck and the distance from elbow to armpit is one head height. The distance from wrist to elbow is slightly more than one head height (the same as the length of the foot). The length of the hand is about three-quarters head height. The elbows fall just below the rib cage.

LEGS
The legs are just over half of the overall height. From the bottom of the kneecap to the crotch is the same length as the bottom of the kneecap to the soles of the feet. The upper leg (thigh) is almost as wide as the head. The knee is two head heights above the bottom of the foot. The lower leg (calf) is the same width as the neck, and the length of the foot is slightly more than the height of the head.

Constructing a Female Pose: Front View

1 This drawing is of a young woman in her late teens/ early 20s. Start with a stick figure drawn with light pencil marks to work out the character's proportions in her straightforward front-view standing pose. The feet placed close together and the hand on the hip help to denote a feminine stance.

2 Flesh out the character using solid shapes – a combination of rounded triangles, ovals and circles will keep things simple. While people in the real world come in a large variety of shapes and sizes, most manga females are all about skinny waists, sizeable breasts, wide hips and long legs.

3 Erase the initial stick figure guidelines. When drawing front-on poses like this, remember to observe symmetry – the shoulders should be equal width, the left thigh should be as thick as the right thigh and so on. I've begun the hair with a general shape to determine the size and length.

4 Next, give the face and hair some detail. To make things look a little more dynamic, add some movement to the hair as if it's blowing in the wind – the movement of the air is from the left here, so the strands are all blown to the right. Add a tight-fitting outfit. This is more or less a case of introducing folds to the parts of the body that bend and twist the most such as the elbows and knees, as well as along the middle zipper line.

5 Begin the inking process. I used the software PaintTool SAI in this example. The sketch in the first step wasn't too messy to begin with, making it fairly easy to trace over the top. When inking, especially in the case of fold lines, remember to taper the ends of each line to a point to keep things looking slick. Manga doesn't often use much variation of line widths, but try to make less relevant details such as folds thinner than the character's outline.

6 Decide which colors to use. There's always the option to go with something unusual such as bright pink or green hair for manga characters, but I'm going to keep the hair a more natural dark brown and introduce a bright neon pink to the outfit. Keep your color palette limited for maximum effect, perhaps using just one or two more vibrant colors to set things off.

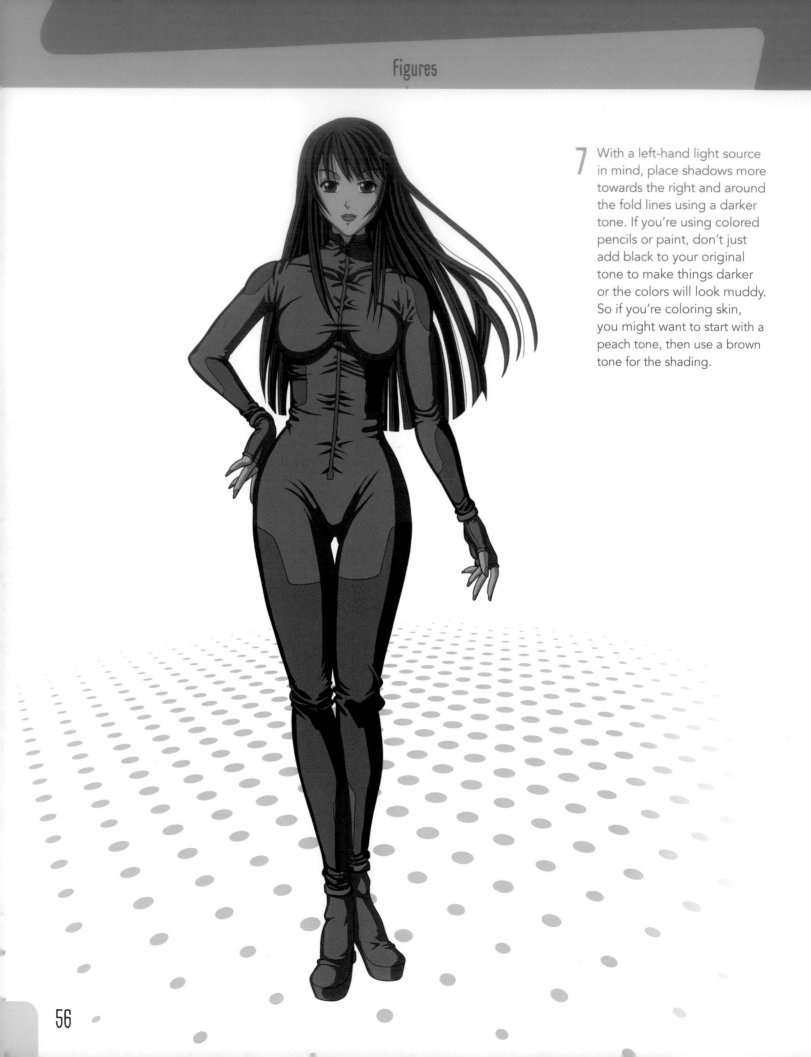

7 With a left-hand light source in mind, place shadows more towards the right and around the fold lines using a darker tone. If you're using colored pencils or paint, don't just add black to your original tone to make things darker or the colors will look muddy. So if you're coloring skin, you might want to start with a peach tone, then use a brown tone for the shading.

8 Rather than stick with an anime cel look, I decided to go for an airbrush style by blending in the existing shadows and adding extra shading to really make the artwork pop and look more three-dimensional. Add the finishing touches such as light bands to give the hair some shine.

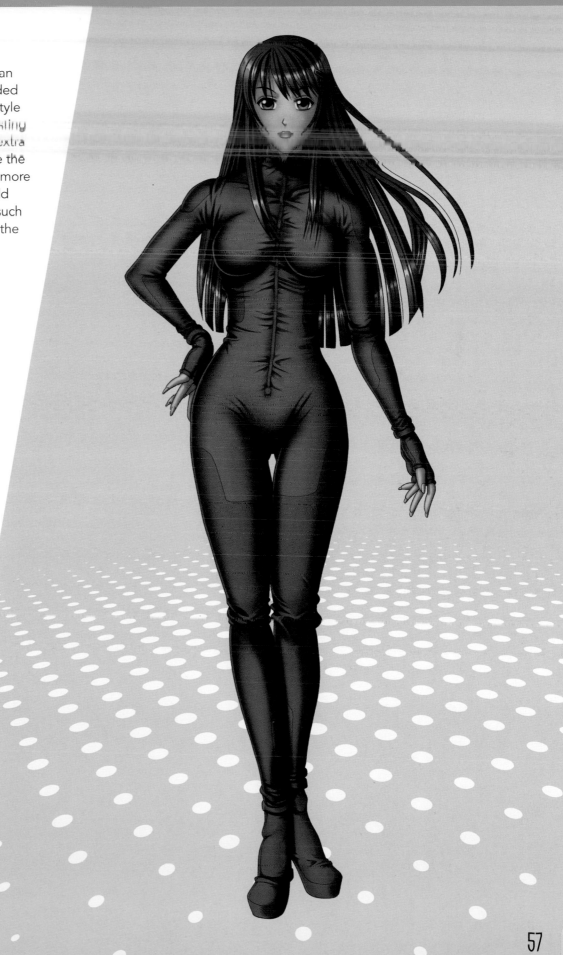

Constructing a Male Pose:
Three-quarter View

1 With your character facing at an angle to the left, start with a penciled stick figure to work out the proportions. Three-quarter views will involve overlapping limbs such as an arm behind or in front of the torso.

2 Flesh out the character using solid shapes. I want to keep this figure more within the realms of reality by not over-simplifying or exaggerating the body parts a great deal.

3 Erase the initial stick figure guidelines. Manga males are often on the lean side, but I want this guy to have a little more bulk to help illustrate some muscle definition in the next step.

4 Introduce a tight outfit over the top, making it a little easier to understand the underlying anatomy. Creases are placed around the joints and bends. As long as the figure is in proportion up to step 3, adding the details such as folds and hair is a lot more straightforward than it might at first appear.

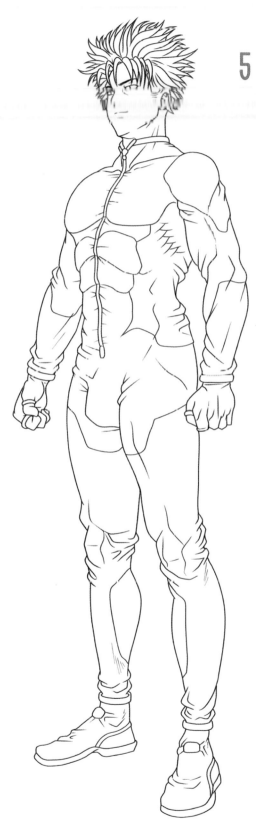

5 Clean up the sketch by inking the outlines using a pen or digital software. Manga linework is usually finer with less variation compared to a typical Marvel comic character, for example.

6 Decide on your colors and put them in. I've kept a similar color palette as the front female pose.

7 This has a front-facing left-hand light source, so place shadows towards the right and around the fold lines and creases using a darker tone. Think about how shadows will contour around the shapes on the body. For example, light does not reach the areas under the chin, beneath the armpit or below the knees.

8 Blend the shadows to create a more realistic, three-dimensional form. If you want to achieve a soft, smooth quality to the artwork like in this example, use colored pencils, airbrush or digital. Paint or markers can look great, but may be a little more blotchy or textured.

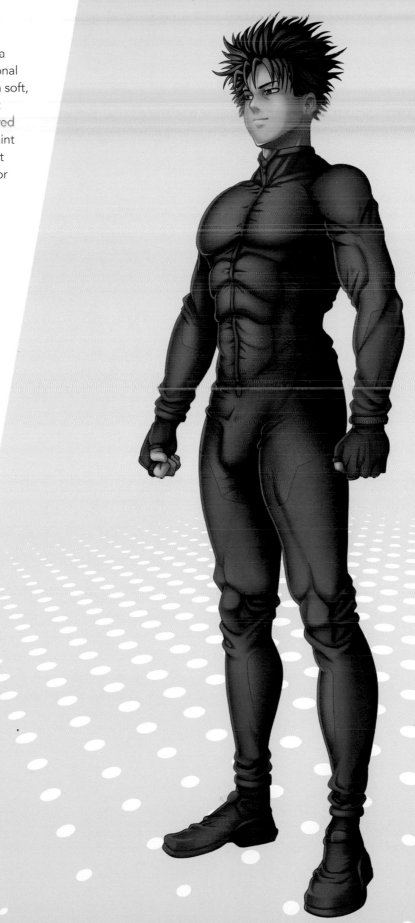

Constructing a Female Pose: Rear View

1 Replicating the same build and pose of the character shown in the front view, start with a stick figure guide to work out proportions.

2 Flesh out the character using solid shapes. The major difference here compared to a front view is to map in the shoulder blades and buttocks. Even though the hair will cover most of the back, it's a good idea to draw in the body outline to help you understand how she would look without the hair overlaid and make sure proportions are correct.

3 Erase the initial stick figure guidelines. At this stage double check that you're happy with the pose and proportions before adding any more detail.

4 She'll be wearing a figure-hugging suit, and creases and fold lines will be found around the joints and where the figure bends – elbows, knees and lower back. Give a little movement to the hair, using curved lines to stop it looking lackluster.

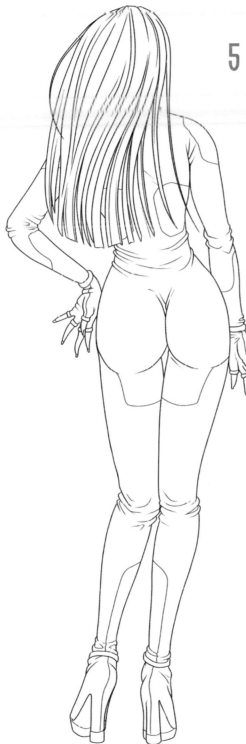

5 Ink the outlines using your choice of pen or digital software. If your pencil work is very neat or you like a rough, sketchy look to your linework, you may even consider skipping the inking stage. I chose to ink using PaintTool SAI to make the lines more thin and delicate.

6 Choose your color scheme. I decided to go for a more girly effect this time with pale blue, pink and light blonde hair.

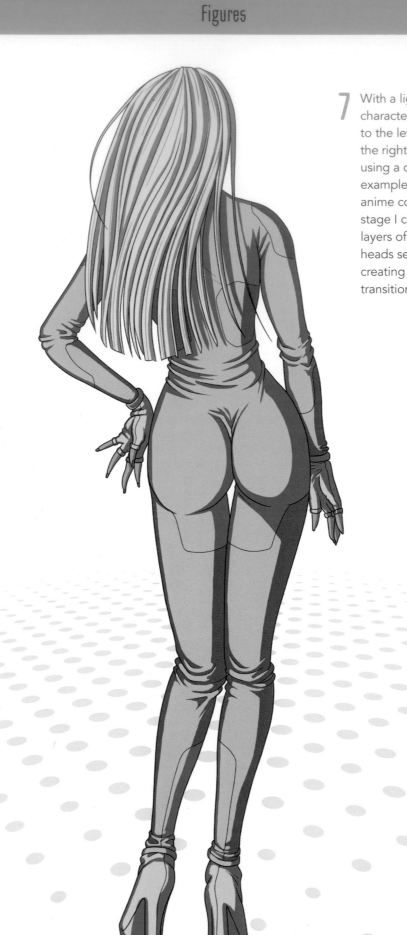

7 With a light source illuminating the character from a three-quarter angle to the left, place shadows towards the right and around the fold lines using a darker tone. As with previous examples, I've used the two-tone anime coloring style. For the next stage I can either build up additional layers of shadow as seen in the heads section or begin to render, creating smooth, gradual tonal transitions from light to dark.

8 By blending tones together while introducing lighter highlights and an extra layer of shading, a more three-dimensional image can be created. Keep gradients of colors gradual and smooth to make the body, arms and legs look more rounded. You might want to add additional patterns or colors to the design afterwards. In this case, I've added some pink streaks to the hair and also colorized the line art itself for a more realistic effect. This is an easy change to make when working on digital layers, but if you're using traditional media such as colored pencil or marker you won't have the opportunity to tweak or recolor parts of the image later on, so plan ahead with your color schemes. At the step 5 inking stage, for example, you might want to consider using a brown outline for the skin areas rather than black.

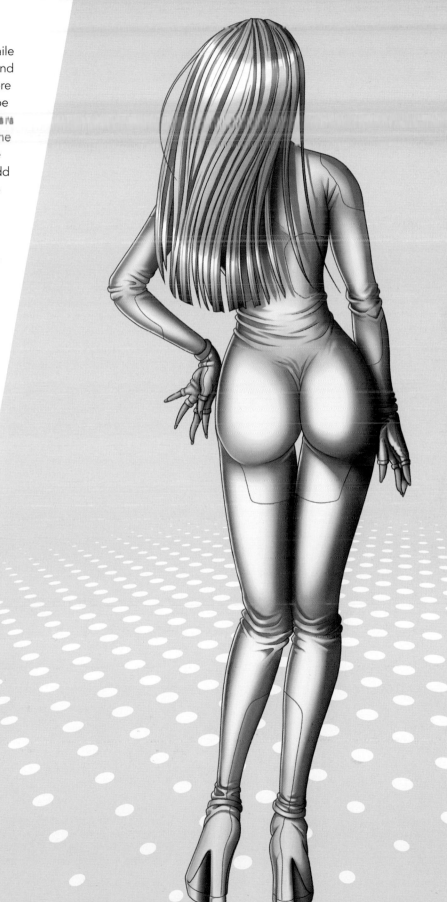

65

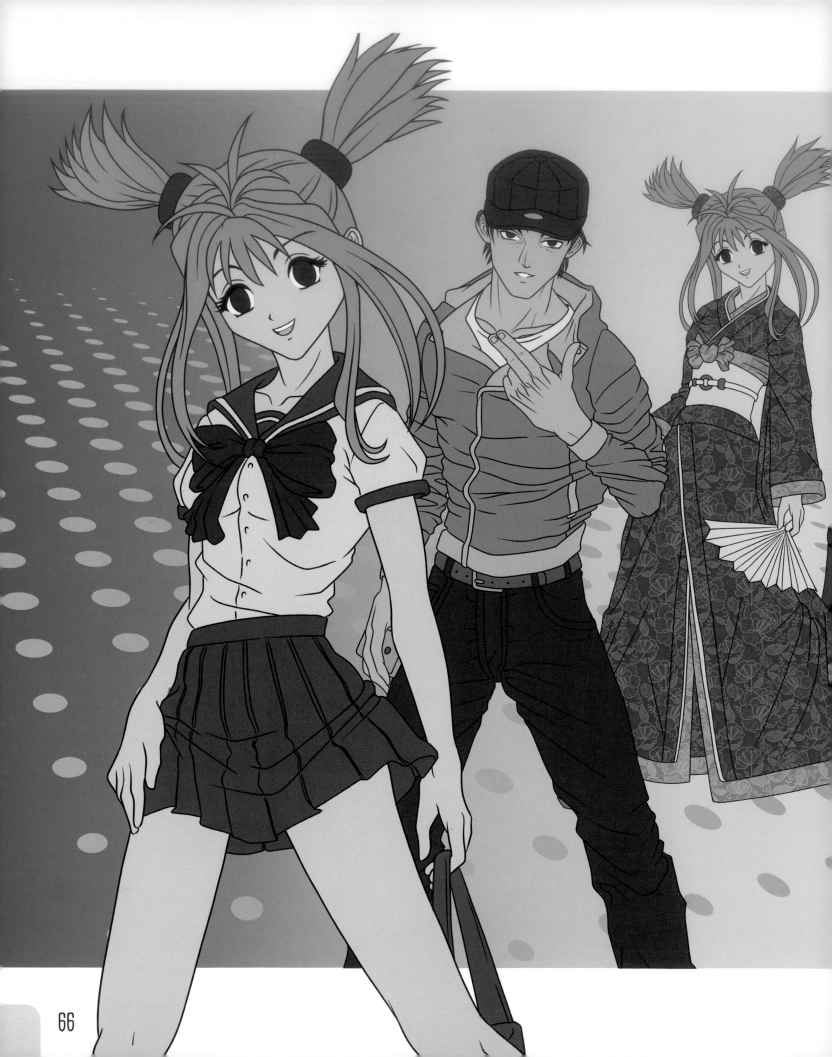

Clothing
and Accessories

Hairstyles, facial expressions and body language can say a lot about a person, but their outfit will add an extra dimension to their personality. Consider clothing as a way to further express who your character is – what they do for a living and what their interests and skills are. Clothing plays a key role in the manga aesthetic, often being clean, slick, stylish, simplified by translating folds into single lines, yet detailed enough to describe form and display final touches such as trim, patterns or seamlines.

It's a good idea to spend time studying day-to-day fashions to gain an understanding of how clothes look and how they fit without interfering with the functioning of the body. Look at modern and historic armor, too. Observe how thick, dense material which doesn't have a lot of give in it will cover chests, backs, thighs and shoulders, while more flexible material will be used for the joints to accommodate bending and rotating.

Drawing folds is the trickiest part when it comes to clothing. It's possible to keep your style simple to avoid putting in a lot of them, but I like to add enough to make an outfit look detailed and believable. Textiles come in many different fabrics, colors and textures, and it's important to consider the fabric weight to determine how the folds will look; heavier material will fall straight down, producing fewer folds, while something light and thin has more potential to wrinkle and crease. As a general rule, the main folds will originate from wherever there are joints. You won't find many folds halfway along the thigh, but you will around the knee, or where clothing gathers towards the bottom at the ankles. As with the long hair seen in previous chapters, use a little artistic licence to add movement to material as this will give it more visual impact.

Notice how both modern and historic fashion has been given appeal with pockets, buttons, trim, patterns and accessories, then feel free to go over the top with exaggerated, impractical coats, hats or shoes. So long as a character can freely move around, bend and twist, anything goes. Characters wielding huge weapons heavier than their own body weight isn't unusual within the manga and video game world. Often, so long as it looks cool, you'll be forgiven for gravity-defying clothing or accessories. Experiment and see what kind of crazy outfit designs you can come up with. At the opposite end of the spectrum, practical and modest style is great for school uniforms, military wear or anything within a more realistic setting.

Clothing

I've included a selection of clothing to show a few different designs along with basic folds. Notice that fabric is often pulled downwards by gravity, and the direction of folds will appear more diagonal than horizontal. Folds can be indicated either by a simple line, as in these examples, or by shading. See if you can figure out where to place shadows on these, working out where light does not reach and where shadows will be cast. Imagine the light source is coming from the left; shadows will be cast towards the right of the fold. If light is coming from above, place the shadows underneath the fold. The bigger and more pronounced the fold, the more it obscures light and casts a greater shadow.

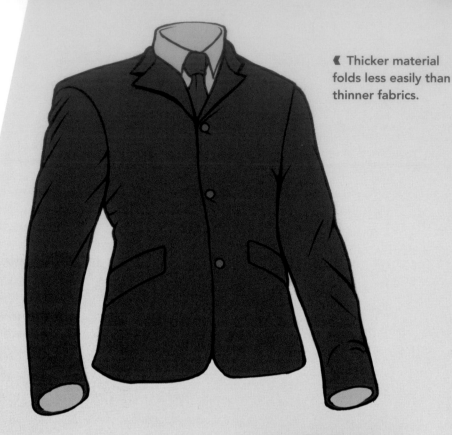

❰ Thicker material folds less easily than thinner fabrics.

❱ Depending on the style, a pair of jeans can contain a lot of detailed folds around tight areas, areas that bend and at the bottom where material gathers.

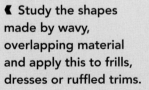

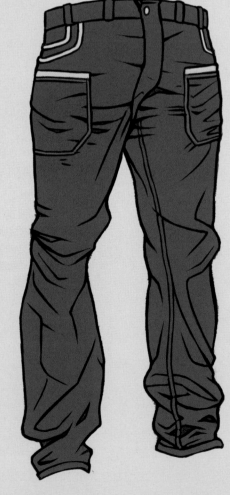

❰ Study the shapes made by wavy, overlapping material and apply this to frills, dresses or ruffled trims.

❯ Consider utility and appeal – a very practical garment can be made attractive with a few decorative elements.

❯ Notice how fold lines originate from the elbow or other points of the body that bend.

❯ Experiment with sheets of cloth and different material to see how they fold when hung or draped.

❮ You don't need to go over the top with detailed folds – adding trim or piping to an outfit prevents clothing from looking too minimal.

❯ Add creases to make skin-tight garments more believable.

69

Dressing a Character

There are a number of costumes, outfits and uniforms that crop up often in Japanese anime and manga, so it's worth spending some time studying them. These include samurai, ninjas, maids, nurses, miko (shrine maiden/priestess), school uniforms, suits, cat girl cosplay, kimonos and Lolita fashions. If you're trying to figure out how to dress your character, start with an unclothed figure or base, then layer an outfit on top. This not only helps to make sure the clothing fits over the body and conforms to the contours beneath, it gives you the opportunity to check the figure proportions are correct before being concealed by clothing.

As with many of the examples in this book, I've included quite a lot of detail here to illustrate as many potential fold or stretch lines as possible. You can simplify if you wish to by drawing in fewer fold lines and concentrating more on the outline shapes.

Male underwear
This is pretty straightforward – mainly briefs which stick to the shape of the body.

Gakuran
Middle school or high school (ages 15–18) boys' school uniform in Japan. Blazers and shirts are often worn as an alternative.

Shinobi

Ninjas are often depicted in dark colors to complement their tendencies for espionage, assassination and combat. To give this custom outfit some individual flair, I added a red scarf.

Casual attire

Jeans, trainers and hoodie – a typical outfit for many young guys.

Female underwear

The basics are a bra and knickers, but they can be a lot more elaborate than men's underwear, with bow details or lace.

Sailor fuku

Middle school or junior high (ages 12–15) girls' school uniform in Japan. Black plaid skirts, shirts and blazers are sometimes worn instead, especially for older girls.

Kimono

A kimono would usually wrap around the legs more and be narrower at the bottom, but because of the wide stance, I tweaked it to allow an opening at the front. Kimonos come in a huge variety of colors and patterns.

Meido

The Japanese maid costume is a popular outfit often worn by anime cosplayers, or by staff working at themed 'Maid Cafés' in Japan and other parts of the Far East.

Accessories

When you have your character's basic outfit down, consider adding accessories to complete their style. Take a good look at real-world accessories, which are often very functional and easy to make sense of on paper. Once you're familiar with them, it becomes easier to adapt them into futuristic sci-fi or medieval fantasy items. I've drawn several examples of accessories you might want to give to a character. Others might include backpacks, jewellery such as necklaces and bracelets, watches, mobile devices, food items, and a water bottle.

❰ Adding a hat is an easy way to give your character a little extra individuality.

❰ Big headphones are always a popular addition to manga characters.

❱ Goggles might sit above the eyes on the forehead, perhaps half covered in long manga hair spikes.

❰ The curve of a belt or bracelet can help to illustrate the angle of a torso or limb.

❰ Cute manga girls often like cute cuddly toys and plushies.

❰ Placing a few shopping bags in the hands is a fairly straightforward addition.

❰ People often wear accessories for sentimental reasons, such as a pendant passed on to them or a lucky hat they often wear.

Weapons

Manga stories often have conflict as a theme, so the ability to draw a variety of weapons for different characters and settings is always a good thing. Consider functionality – how will the weapons be held, how will they be transported when not in active use, what would be a character's weapon of choice and why?

❰ Adding some 'bling' or gold plating to a gun might suggest the owner is cocky, wealthy and trying to show off how powerful they are.

❱ Some weapons can be an extension of the body, such as spiky gauntlets or armor.

❱ Consider secondary weapons such as daggers, grenades or stars for throwing.

❰ The bigger the gun, the better the stopping power!

❰ Swords are among the more common weapons and are luckily relatively easy to draw.

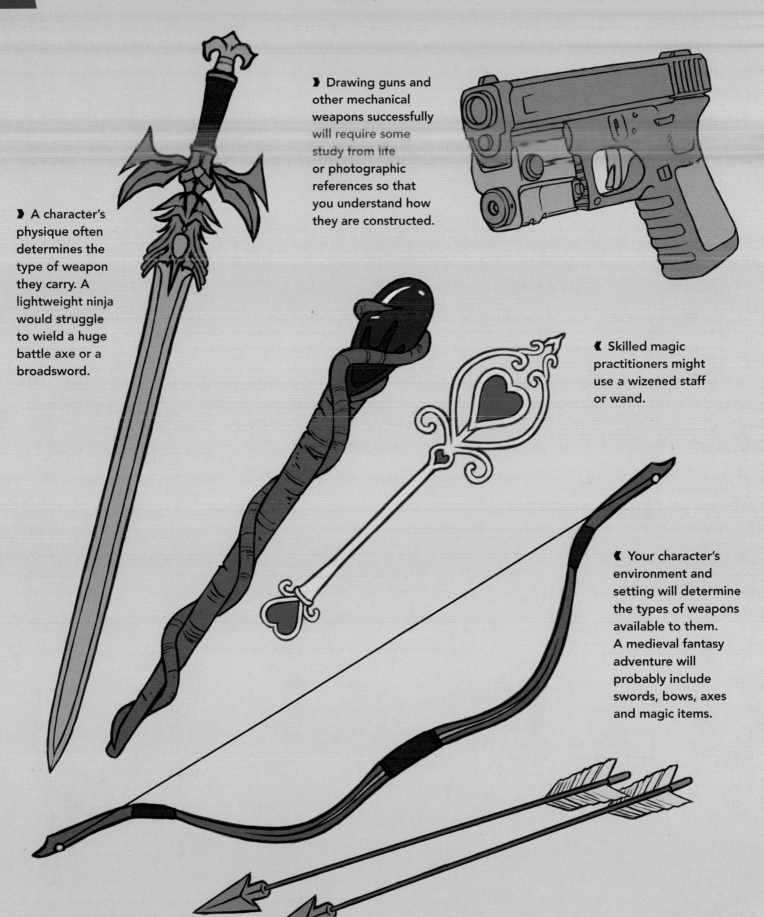

❯ A character's physique often determines the type of weapon they carry. A lightweight ninja would struggle to wield a huge battle axe or a broadsword.

❯ Drawing guns and other mechanical weapons successfully will require some study from life or photographic references so that you understand how they are constructed.

❮ Skilled magic practitioners might use a wizened staff or wand.

❮ Your character's environment and setting will determine the types of weapons available to them. A medieval fantasy adventure will probably include swords, bows, axes and magic items.

77

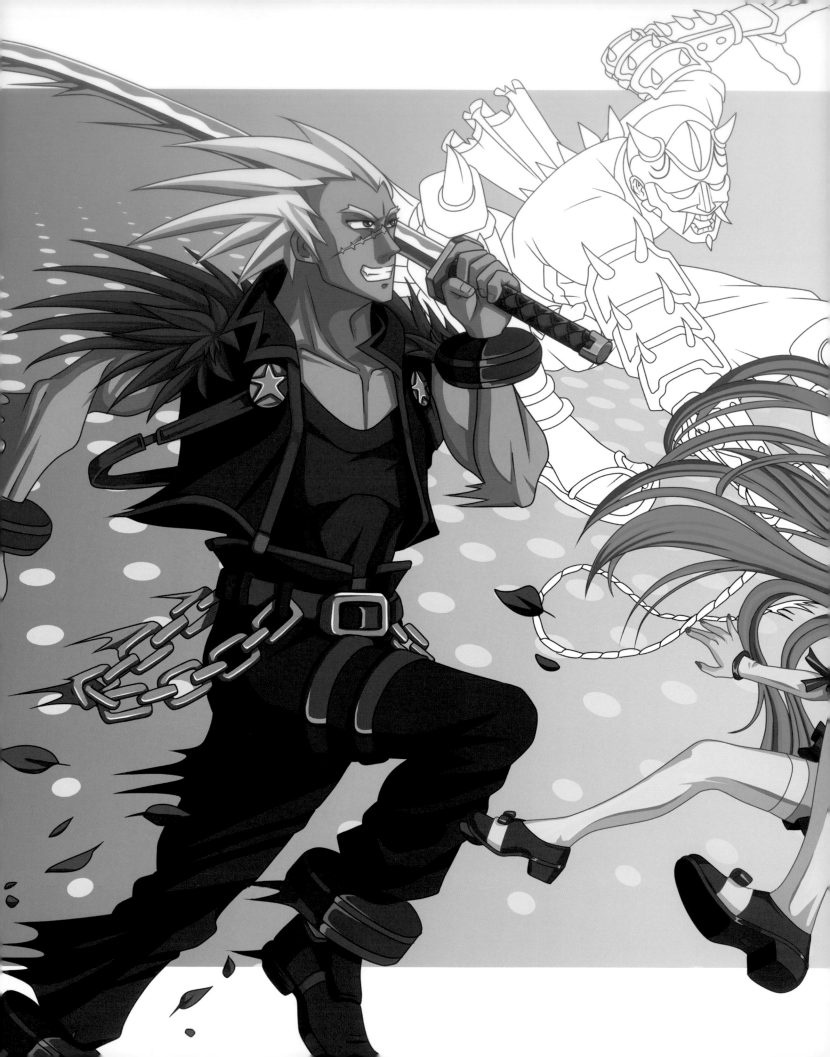

Action

After acquiring some knowledge of basic anatomy and body proportions, the next step is to pose your characters at different angles and show them performing various tasks to make them look more dynamic and interesting. From there you can create more complex scenes or even a comic-book page. This will probably be a little tricky at first, but finding some reference images on the internet or taking photos of yourself or friends in a variety of poses will be a big help. When choosing a pose for your character, think about their personality and how they move. For instance, when walking, one character may strut along confidently with their head up high and shoulders back, while another may drop their shoulders, drag their feet and walk along with their head hung low. The mood you show depends on the pose, as well as the facial expression. Try to imagine how you stand or move in different moods.

Earlier chapters in this book showed construction methods being broken down into 10 steps. With these action examples I'll be using only four steps, although if you prefer to you can break down the process even further to 10 steps or more using the principles featured previously. Alternatively, try jumping to step 3 by copying out each line drawing, then use the colored step 4 version to help with your shading. I've covered falling, running, swinging and fighting; consider how you might apply what you've learnt so far about figure drawing and clothing to the action examples.

Falling

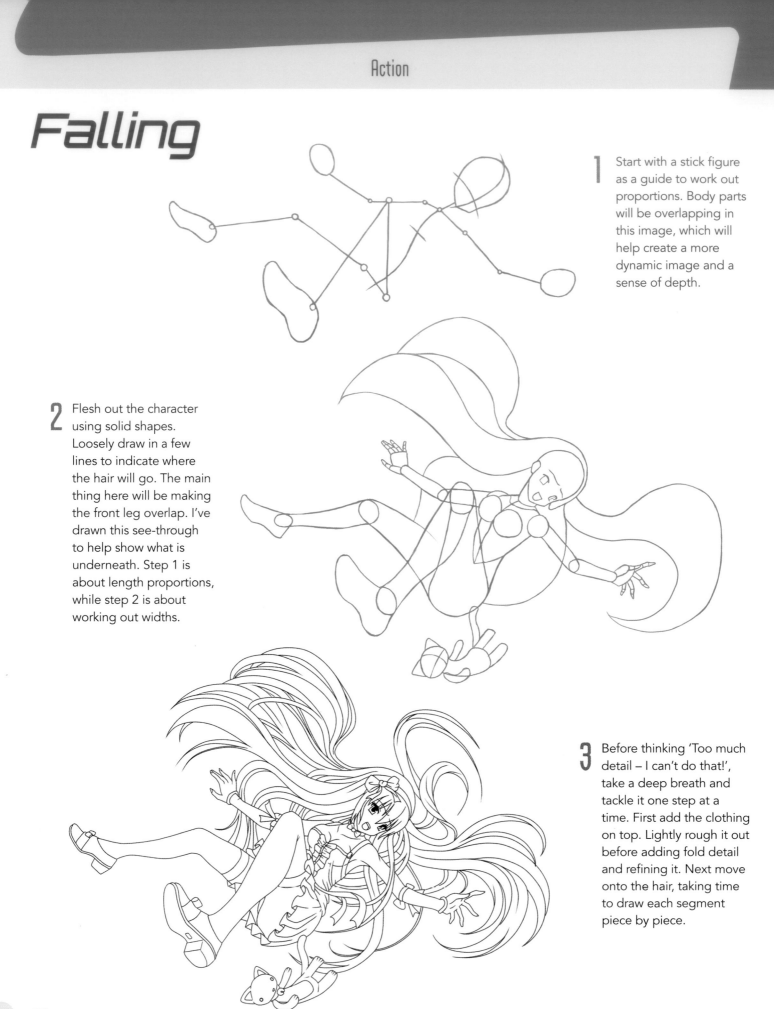

1 Start with a stick figure as a guide to work out proportions. Body parts will be overlapping in this image, which will help create a more dynamic image and a sense of depth.

2 Flesh out the character using solid shapes. Loosely draw in a few lines to indicate where the hair will go. The main thing here will be making the front leg overlap. I've drawn this see-through to help show what is underneath. Step 1 is about length proportions, while step 2 is about working out widths.

3 Before thinking 'Too much detail – I can't do that!', take a deep breath and tackle it one step at a time. First add the clothing on top. Lightly rough it out before adding fold detail and refining it. Next move onto the hair, taking time to draw each segment piece by piece.

4 Put in your chosen colors, adding darker tone around the outer edges of the shapes to create a more three-dimensional look. Most of the colors on this one use three tones - a base tone then two layers of darker color for shading. Manga 'speed lines' or 'action lines' added to the background help to create an added sense of movement.

Running

1 As usual, begin by drawing a stick figure as a proportion guide. Running poses, and action poses in general, often start with one arc line. In this case there is an arc running from the top of the head down to the foot closest to the floor. This curve helps to illustrate the direction of movement from left to right.

2 Create the body masses using basic shapes. These foundational anatomy proportions are key to making sure your work will look good when it's finished. While the fun part might be adding details such as outfits and accessories, it's important to get the base right to save time in the long run. You don't want to be 30 minutes into drawing a complex design on a character's T-shirt before you realize the torso is too short and you need to redraw it from scratch!

3 Add the clothing, hair and sword. The direction of the outfit details and folds is all towards the left to help show the character is moving towards the right. Notice how I've also added left-pointing spikes to break the line art, symbolizing motion-blur. A gust of flying leaves also helps to add another layer of action and movement to the drawing.

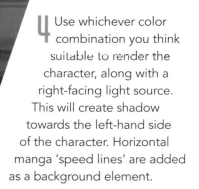

4 Use whichever color combination you think suitable to render the character, along with a right-facing light source. This will create shadow towards the left-hand side of the character. Horizontal manga 'speed lines' are added as a background element.

Swinging

1 This time our stick man will be posed in a Spiderman-like jumping position. As there is a lot of bend to the back, the torso will appear shorter and the right shoulder will obscure the chest and abs. The overlapping body parts will help to add a lot of depth in the image.

2 This pose really starts to take shape as the solid masses are added. As with all these action examples, keep your guidelines light and feel free to be more sketchy than I have been; this step is about getting basic shapes in place so that you can understand the pose.

3 Add the outfit of your choice – I've gone for a masked Japanese ninja warrior. And, of course, add the rope coming down from the top right to make it look as though he's swinging towards us and to the right.

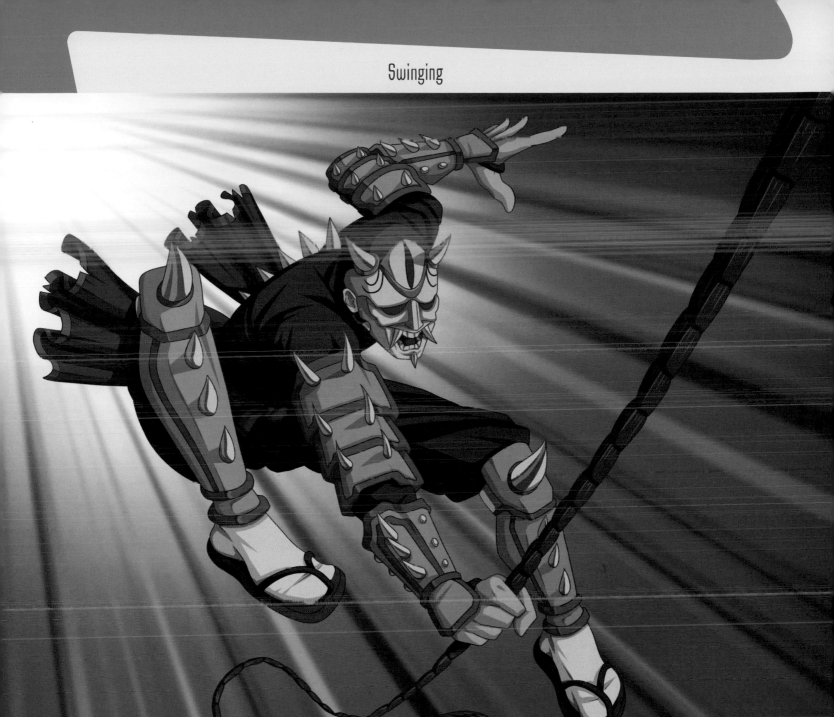

4 I wasn't sure which colors to opt for with this one, so I experimented with some different combinations before making my final decisions. You might want to do the same by scanning your linework and then printing out a few copies to play around with before committing the color, or saving an extra copy or two if working digitally. With a little extra thought, it turned out great in the end.

Fighting

1 This artwork is a little more complicated by virtue of having two characters interacting with each other. The idea is for the bigger stick man on the right to have thrown a punch while the smaller stick man on the left has put up his arm to block it.

2 Bulk out each of the characters in a muscle-bound *Dragon Ball Z* style – they're both warriors, after all. The left character is posed in a typical three-quarter view, while the right character is leaning in more, exposing the tops of his shoulders. Keep in mind that the chest and shoulder lines of the two characters are parallel.

3 I wanted the left guy to be dressed in a casual outfit, with the right guy in a judo or karate *gi* (uniform). Remember to add some movement to accessories like the necklace and belt.

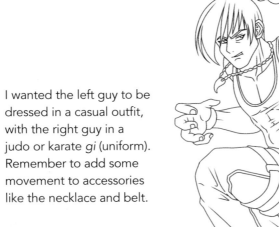

4 To make this drawing more aggressive and intense, I used a strong red background and added inward-pointing manga 'action lines' to focus on the point of contact in the middle of the image. To give it a more authentic Japanese manga flavor, katakana characters were added on top to show a 'Pow!' sound effect.

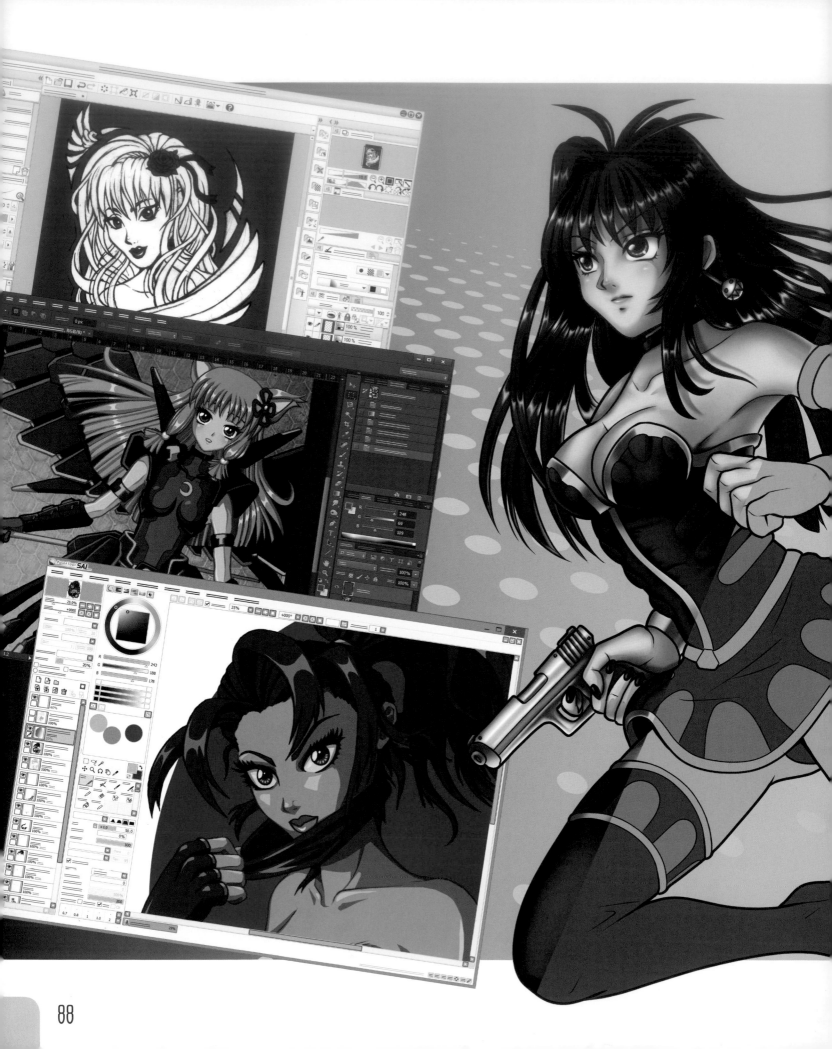

Color and Tone

Producing artwork rendered to a professional standard is something that can take a long time to learn and achieve, although there are many simple rules based on reality which determine how much shading to use and where to place shadows and highlights. Even manga needs to retain a sense of believability by having light affect characters or objects in the same way it works in real life.

Having said that, the goal of any artist is to communicate effectively through their work. The most realistic image will not necessarily create focus and clarity. As with drawing manga eyes, where there's no need to draw each individual eyelash, it's not necessary to spend massive amounts of time rendering unimportant elements of the image. Adding a huge variety of tones or details to every surface such as skin pores, veins on leaves, cracks in brickwork, ants on the floor and so on will not add a lot to your image, and may even make it too busy, unfocused and hard to 'read'. So, you'll need to make decisions on how much detail to add and how to limit your color palette (the selection of colors used in an image). While the majority of comics produced in Japan tend to focus on linework, often with a monochromatic interior, every manga cover, magazine advert, animation or game intended to grab a viewer's attention will need color. Coloring effectively is more than a case of simply staying inside the lines. It's a way of representing a character's emotions, personality and preferences; it can set the mood of a scene and a powerful atmosphere, and of course it's a way to show off your unique, individual style.

Color Terminology

Many people learn which colors work best together through trial and error while creating their artwork. However, there are several tried and tested theories as to what makes a strong image and which color combinations look most effective. Knowing these can quickly help improve your standard of work.

Primary colors

Red, blue and yellow are known as primary colors. They cannot be created by mixing any other colors, but when they're mixed with each other they can produce every other color. In digital terms, mixing paint is a case of interlacing colored pixels at different percentages.

Secondary colors

These are green, purple and orange, created by mixing the primary colors. Yellow + blue = green, blue + red = purple, and red + yellow = orange. These can be seen on the 'color wheel' between their respective primary colors.

Tertiary colors

These are yellow-orange, red-orange, red-purple, blue-purple, blue-green and yellow-green. They're created by mixing one primary with one secondary color.

Analogous colors

This term describes groups of three colors which all sit next to each other on the color wheel, for example, yellow, lime green and green.

Value

This refers to the lightness (more white) or darkness (more black) of a hue (hue being another name for a color, such as red or green). A value is often also referred to as a tone.

Warm and cool

Red, yellow and orange are associated with the heat of sunlight, fire and lava, while blue, green and purple are found in the cooler aspects of the natural world such as ice, night time and water. Some people prefer cool colors as they feel calmer, while warm colors convey more energy.

Intensity

Also referred to as 'saturation', intensity is the brightness or dullness of a tone. Varying the saturation of colors in an image is a good way of drawing the viewer's attention to a certain part of it – the more vibrant and intense the color, the more significance it has. A gray, dull tone can be used on less important parts of an image.

Complementary colors

The opposite hues on the color wheel are described as complementary colors, for example red and green or blue and orange. Using such schemes can be tricky, but they provide the most vibrant color contrast. Stick with a dominant, main color such as blue, and then use orange for smaller touches or as a secondary light source for maximum effect.

Color palette

This term describes the collection of colors used within your image. You'll need to limit your palette to two or three main colors to unify the image and avoid it becoming too chaotic.

Light and Shade

So far we've looked at several character examples which used shadow and light techniques to make the artwork spring into life in a more three-dimensional form. Shading can be a bit tricky at first but it's not as difficult as it seems. It's all about figuring out where the light source is coming from, where it will hit an object and what shape the shadows will take.

LIGHTING AN OBJECT ❯

Consider the shape of the object from which you are applying a cast shadow. Every shape has its own unique cast. Spheres have a circular, elliptical shadow, cubes and cylinders have a rectangular shadow, and pyramids, as you would expect, throw a triangular shadow.

Notice how rounded objects like the sphere's surface have a gradual gradient shadow – it becomes darker further away from where the light touches the surface. On a cube, light may not reach one or more visible sides at all, resulting in certain planes becoming completely darkened. While it may only be subtle, the top of a pyramid is closer to light from above and is therefore a little lighter than the bottom.

Anime art is often drawn in a two-dimensional cel style. This uses two to four simplified solid tones to create the illusion of a more three-dimensional look. In real life objects do not have outlines, but you'll find outlines in nearly every piece of anime and manga artwork you see.

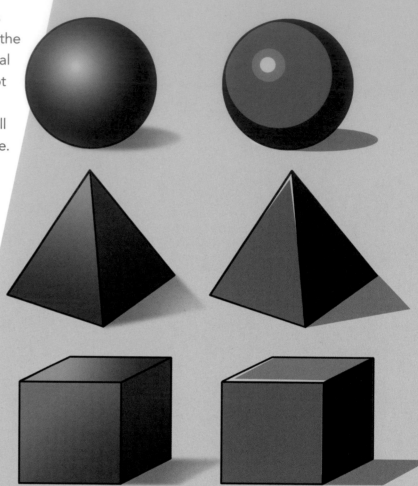

CONTRAST

Often the most effective artworks make use of maximizing contrast, varying intensities of certain colors or other elements within the image. The lightest and brightest parts of an image are those you most want to draw the viewer's attention to. With a figure, this might be their eyes or their magical weapon, for example. If there is to be a setting, the aim is to keep the character as bright as possible, while dulling down the scenery in the background or foreground. The character will then stand out and become a focal point in the image. Contrast can be created by emphasizing:

❯ **Light and dark**
❯ **Smooth and rough**
❯ **Bright and dull**
❯ **Warm and cool**
❯ **Blurred and sharp.**

RELEVANCE

When you're designing a character's color palette, consider using lots of dark colors, reds or black for a villain, lighter shades of blues and white for a hero, or pinks, purples or pastel tones to convey femininity. Pale colors could be used for an unassuming, calm character, while more vibrant colors could be applied to someone more adventurous and extrovert who doesn't mind being noticed. There may be particular aspects of a character that dictate the color, too: if, for example, you're designing an Ice Queen, use blue tones and white on her outfit to link in with her cold, frosty theme.

LIGHTING COLORS

Lighting conditions affect the natural colors of objects. It's rare for a sheet of white paper to be pure white, for example. If you take it outside on an overcast day, it'll appear more gray. Indoors under a typical domestic light bulb, it'll have a yellow or orange tinge to it. The color of external lighting may not be something to consider if you're simply putting together a character concept, but it's still a good idea to adjust the hues and tonal variations used for a character or object to make them appear relative to their environment.

MONOCHROME

Sometimes hues can get in the way of understanding the power of values and contrast. Experiment with using just black, white and gray mid-tones. Many artists practice their lighting knowledge by producing 'value studies'. These are referenced sketches, drawings and paintings to help them understand how light works on different shapes, forms and textures.

In order to create maximum impact, a full range of lights and darks are key. Using more white can be good for showing stronger daytime light or spotlights, while introducing more black can be good for subdued, night-time lighting.

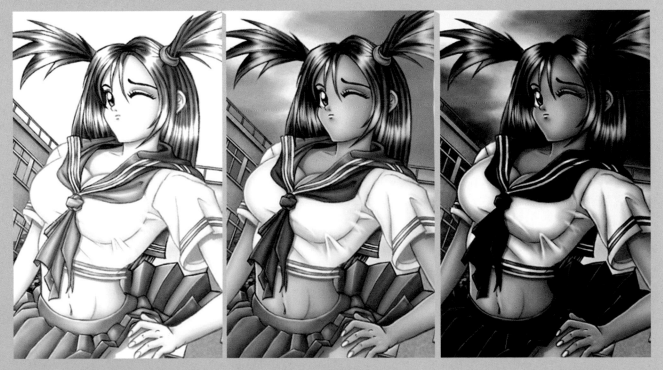

Inking

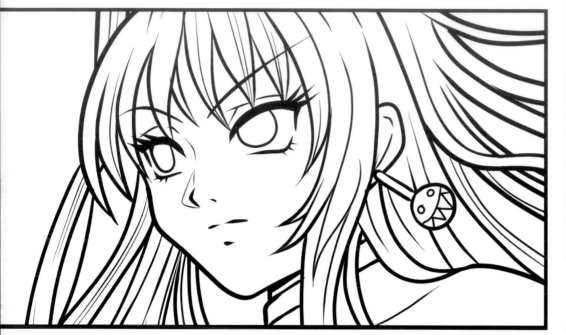

Creating clean black and white art is an important skill that any manga artist needs to master. Most artwork will be created with a pencil, then inked on top before being colored or toned. While the pencil works in a similar way to an inking pen, the pen requires much more precision and patience in order to attain smooth, clean lines.

There are two major methods of inking: digitally with the computer or by hand with pens. Traditional dip pens, or nib pens, use a metal nib mounted onto a handle often made of wood. You simply dip these into a pot of ink and draw, pushing harder or varying speeds and angles to produce thicker or finer lines (line weights). Modern-day pens with a continuous ink supply can often rival traditional nibs and brushes in their mark-making and are a lot easier to control, without the risk of ink splattering over a page accidentally.

A mistake that beginners often make while learning to draw is using only the fingers or wrist during the drawing process. A smooth line needs to be drawn in a continuous arc. Smaller lines may only require moving the fingers slightly, others require pivoting from the wrist, while larger lines need you to lock your fingers and wrist in place while pivoting from the elbow. Using the entire arm increases control, thus producing straighter, more confident lines.

With a pencil you can take it slow, stroking the lines in gently and building them up to be solid and thicker. However, slowing down too much while inking may result in wobbles and make it harder to stay on the correct path.

VARYING YOUR LINES

Line weight and thickness is determined by two factors: angle and pressure. For example, with a brush pen, using just the tip of the pen at a 90-degree

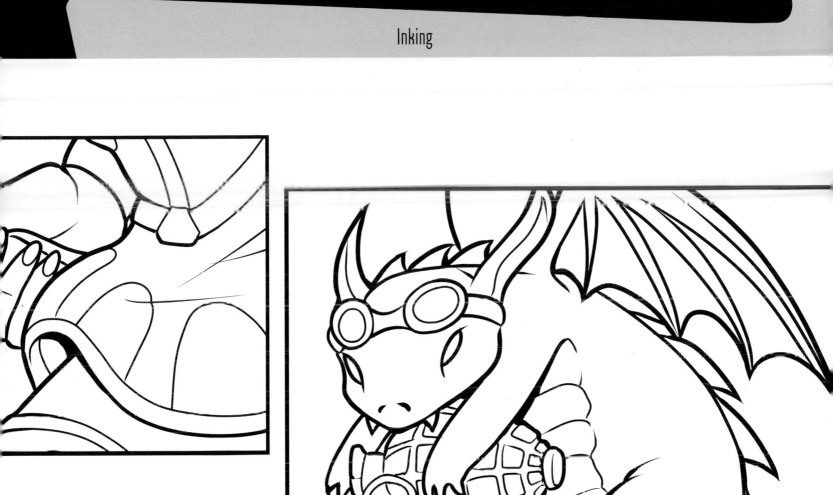

angle will create the thinnest line. Lowering the angle will thicken out the line, as will applying more pressure. This is usually true for a pencil also, but since the tip becomes dulled fairly fast in a pencil, the point may not be at the exact center. Pencils should be rotated to keep the same thickness and avoid over-sharpening.

As well as arm movement and pressure control, good inking often requires planning. Before committing to an inked line, decide where both the start and end of the line will be. Especially if it's to be a long, smooth line, rehearse it first and keep the end point in mind while applying the ink. If you are just focused on the tip of your pen, it can be easy to go off course, then you have to correct your direction halfway through a line, resulting in a slight kink.

FROM SKETCH TO INKING

No matter what type of pen you use, you will need to trace your sketch. You can ink the sketch directly,

then, using a soft eraser, rub the pencil lines away once the ink has dried, or you can use a light box and trace the picture onto a new piece of paper. This second option might be preferable for the beginner as you don't run the risk of ruining your original sketch. Another alternative is scanning and copying your pencil work, perhaps lightening the line art on the computer before printing it out again to ink.

Once the work is scanned you can ink digitally using the computer. I like using PaintTool SAI for that task. Unlike Photoshop, it has a line stabilization feature which helps to prevent wobbles, and it's easy to adjust the pen edge shape and minimum/maximum size of the line while using a pressure-sensitive graphics tablet. However, Photoshop's pen tool does allow you to construct computer-perfect 'vector' curves. There are line-smoothing plug-ins and applications available to download and use with most art and design software, one being Lazy Nezumi.

Digital Color Introduction

As I'm sure most of you have noticed, computers are now an everyday part of people's lives and art too has shifted towards the use of computers and image-making software. Creating, coloring, editing and reproducing artwork has become fast and easy, meaning many artists will eventually gravitate towards making the most of new technology. Certainly every illustrator, concept artist or manga ka (artist), even those who prefer traditional media, will have to gain familiarity with digital technology and graphics software if they are to have a career creating art. At the very minimum, all artists will find it useful to know about scanning, cropping, adjusting colors and saving work at different sizes.

SOFTWARE

Right now it's an exciting time to sample the new software and hardware constantly emerging onto the market. Home computers are at a stage where they work fast and efficiently, and long-standing software packages such as Adobe Photoshop have evolved to a point where the majority of users would be hard-pressed to think how to improve them. For the most part I use Photoshop and have done so since the late 90s. Most professionals working in concept art for games, films and animation will also make use of Photoshop as their artistic weapon of choice, while colleges and universities offer education in the use of this industry-

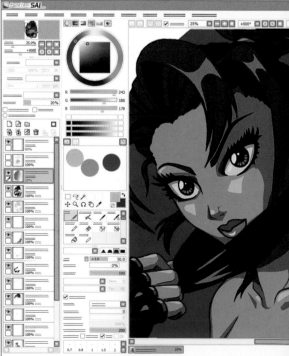

standard application. However, it is one of the more expensive software options, and beginners or experienced artists alike may opt for alternatives such as PaintTool SAI, Manga Studio, Sketch Book Pro, Illustrator, Painter or Photoshop Elements. Many artists like to work with several, for example inking with Manga Studio, coloring with SAI, then touching up and adding effects with Photoshop. Most software companies offer a free 30-day trial, which allows you to have a go and see what suits you before making any outlay.

The interfaces (layouts) for most programs are similar, allowing users to easily select tools and layers and adjust tool settings. Learning the basics with any given application is going to take some time. I suggest first exploring each of the various menus, settings and tools on a new file or canvas to see what they do and familiarize yourself with everything, before giving yourself a small project to complete like 'draw and color a simple face'. To help get you started, I'll provide a basic walk-through of how I draw and color an image using the computer over the following few pages.

EQUIPMENT

Along with your software of choice, you'll ideally need to purchase a graphics tablet, which gives you much more accuracy than a mouse. Huion, Ugee and Wacom all produce a variety of different types and sizes to choose from. I've always used Wacom tablets and now have a small Intuos Pen when traveling and a larger Cintiq display in my studio.

You'll need a scanner, a printer and a good-quality monitor, and of course a computer to plug it all into also helps! Most modern desktop computers and laptops should be capable of running the graphics software available. If you aim to be working with larger files for print, consider a high-spec computer with a speedy processor, lots of RAM and a solid state hard disk for quick file access.

With digital art you effectively have unlimited canvases, paints, brushes and materials at your fingertips and with some practice you'll have no excuses for not creating super-slick artwork again and again. Digital benefits include:

❱ **Unlimited canvases, paints, brushes and other materials at your fingertips**
❱ **After the initial outlay on equipment, the cost of producing art is minimal**
❱ **You can save your work at different stages and go back to edit it**
❱ **Super-flat colors and precise gradients are achievable**
❱ **With textured overlays, you can instantly change the look of artwork**
❱ **You can upload and share artwork on the internet**
❱ **It's easy to print and reproduce your work**
❱ **The software can help artists with shaky hands; short-sighted people can zoom in on their work**
❱ **Perfect lines and curves are possible!**
❱ **Resizing, duplicating or repositioning parts of your artwork is easy**
❱ **And you can UNDO at any time!**

A Figure in Digital Color

Photoshop is my go-to software for art creation and editing. While you may already be familiar with basic Photoshop functions, unleashing Photoshop's full potential will take some practice. Once you master it, however, the results you can achieve with it can be incredible!

After familiarizing yourself with the Photoshop interface, you'll need an understanding of how layers work. These are a fundamental part of digital art. Like a stack of acetate or clear plastic sheets, the lines you paint on one layer won't affect another layer in the Layers panel. If you paint on a layer above you'll cover up the layer underneath, but you won't paint over it. By putting different colors on different layers you can shade each one without adding, for example, unwanted hair color on a girl's face or skin tone on a guy's jacket. Each layer can then be edited individually at any time.

STEP 1
Set up and sketch

Create a new document or canvas. Size-wise, I usually start with the preset 'International Paper – A3' or 'U.S. paper – Tabloid'. As long as your canvas length is 5,000–10,000 pixels and set to 300 dpi you'll get a good result when printing.

Click the 'Create a new layer' icon on the Layers tab. This will add a clear layer for sketching on top of the white Background layer.

Using the Brush tool, select a 12-pixel round brush with 100% hardness and 1% spacing, then check the shape dynamics box, which will be controlled using the tablet's pen pressure. On the brush options bar at the top, set the flow percentage to 10%. Alternatively, the flow can be kept at 100% and brush opacity can be reduced to around 50%. This will create a pencil-like brush with which the lines can be darkened by going over them a second or third time.

Then click the primary/foreground color on the tool bar to bring up the Color Picker screen. Select a blue tone and click OK. Alternatively, select a blue from the Swatches menu panel. Now you're all set up, use the techniques covered so far to help sketch out your character.

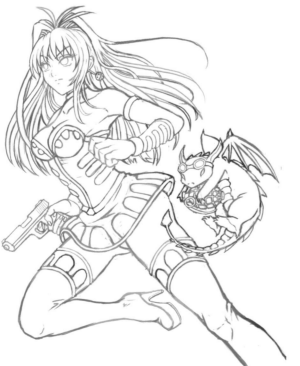

STEP 2
Ink then add flat tones

Once the sketching stage is completed, make another new layer at the top. Use this to create inked black lines on top of the sketch. When complete, the original sketch layer can be deleted, or you might want to save another copy of the file before carrying on with the color process.

Now begin laying the flats – solid base colors which are each placed on their own unique layer. So, a layer for skin, one for hair, one for clothing, another for trim and so on.

Laying flats can be achieved using the Magic Wand tool, the Polygon Lasso or manually by painting them in with the Brush tool. I may use all three methods in the same artwork.

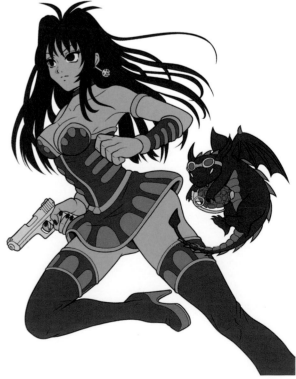

STEP 3
Flat shading

After the flats are laid, lock each of the color layers by clicking the 'Lock transparent pixels' icon on the Layers tab. This will allow you to add shading only to the existing colors, effectively making it impossible to color outside the lines. I use the color picker to choose a slightly darker tone for each color and work out a basic light source using flat cel-style shading.

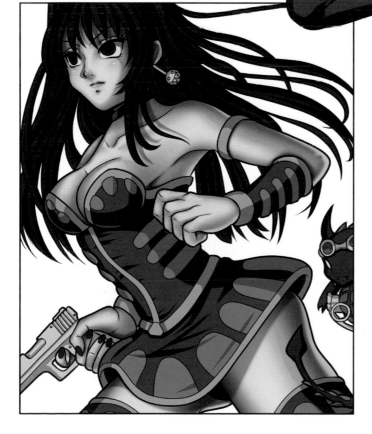

STEP 4
Soft rendering

When rendering, I start with one color/layer at a time. I use a soft brush set to 0% hardness and a low flow percentage (5–15%) to allow me to gradually build up tone and allow more control when blending tones together. I use larger brushes here to spread out graduated tone more evenly.

Once the shading looks nice and smooth, I often open up the image adjustment Brightness/Contrast and tweak the sliders to generate a more vibrant range of tones.

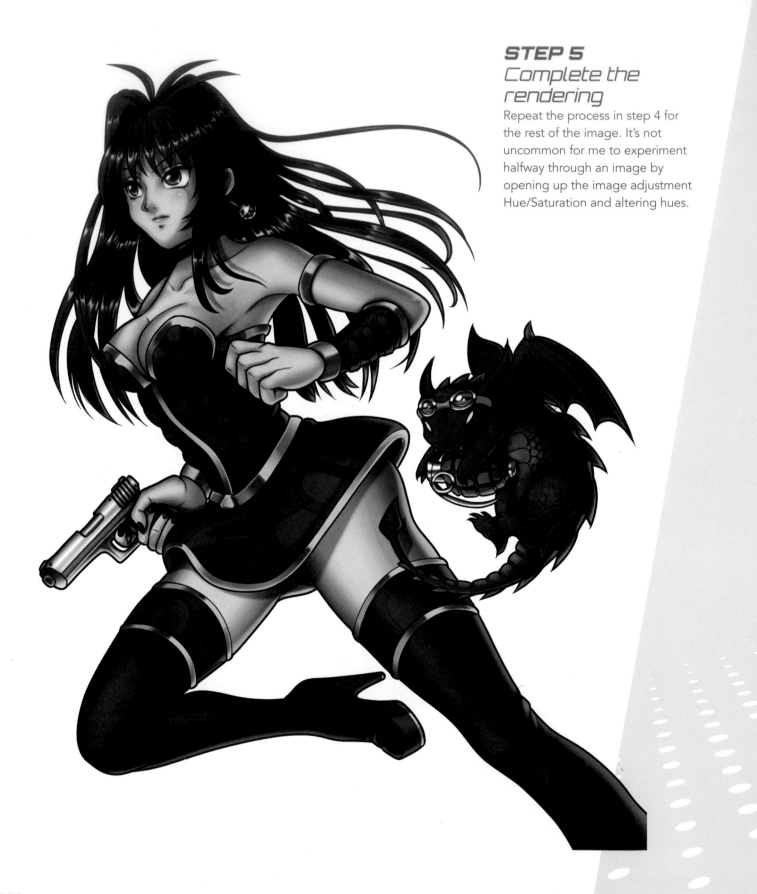

STEP 5
Complete the rendering

Repeat the process in step 4 for the rest of the image. It's not uncommon for me to experiment halfway through an image by opening up the image adjustment Hue/Saturation and altering hues.

STEP 6

Since the linework is on its own layer, it can be colored. For example, the lines which butt up against the skin can be made dark brown and the lines next to the silver trim can be lightened. Colored line art gives a slightly more realistic look and helps to make the art look more unified as a whole.

Add in a background. In this case, I used a photo I had taken, adjusted the Hue/Saturation and Brightness/Contrast and applied a motion blur filter.

Then I added color gradients layers over the top of the image with each layer's color blending mode set to Soft Light. It can be fun to use different colors or gradient fills overlaid on to an image and experiment with Photoshop's various layer blending modes.

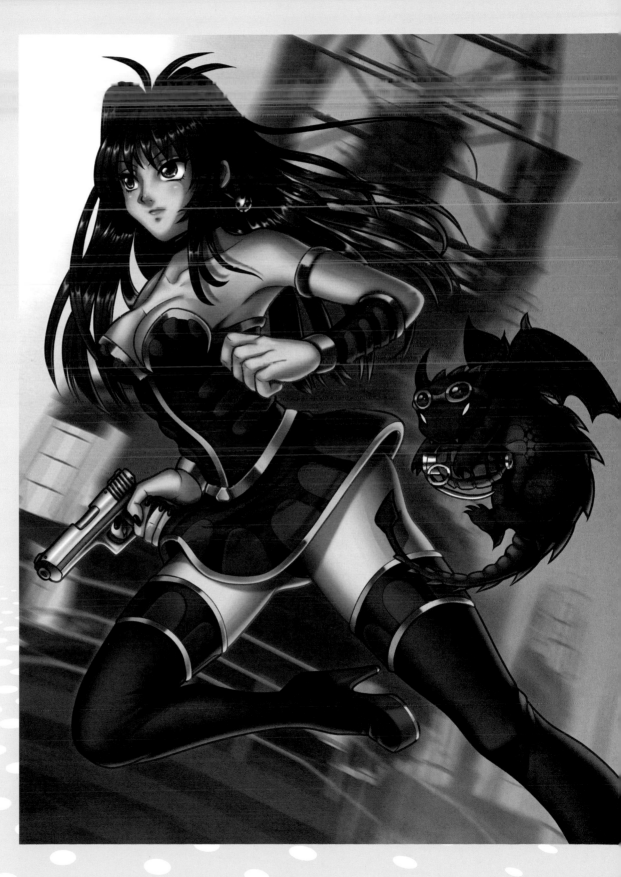

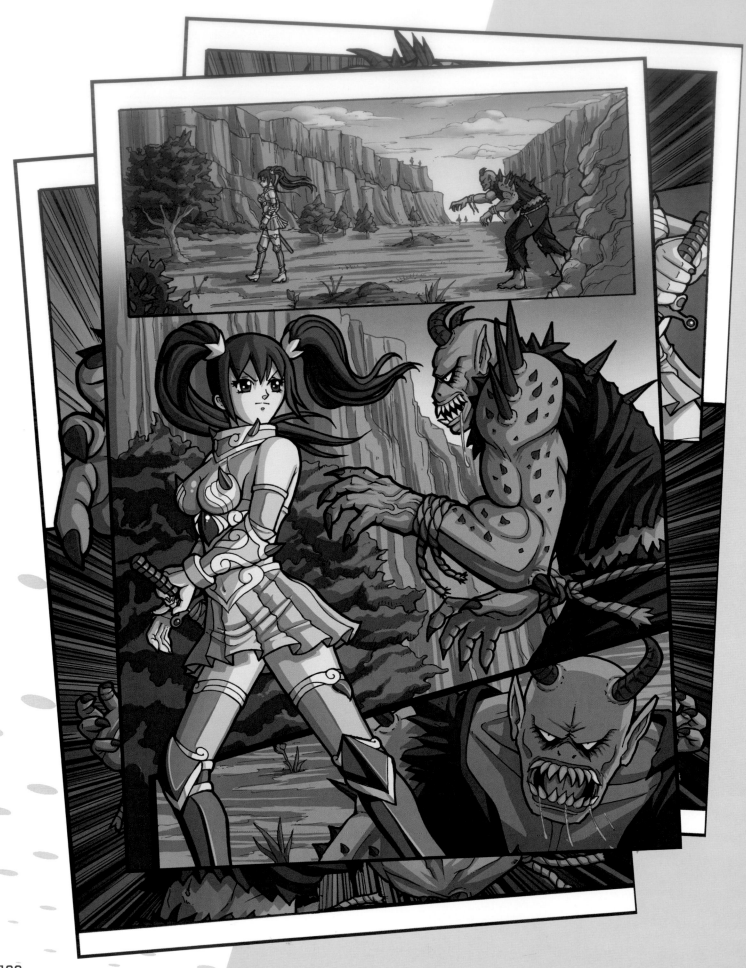

Manga Pages

As you continue to hone your technical drawing skills, you may decide to place your characters in their very own comic strip or manga story. It's great fun thinking about your characters on another level – how their personalities will manifest themselves and what adventures they could get up to. Creating manga pages can be a very time-consuming process, however. You'll need to create characters from various angles, draw backgrounds, props and environments, and maintain consistency so that each panel makes sense and looks coherent. While making a manga story can become a complex project, here are some tips to make it easier and more enjoyable for both artist and reader alike.

The first lesson when drawing a manga page is – don't waste too much time on setting up the story. Ideally, the setup at the beginning of the comic is either so brief it fits on a few pages or, even better, in a few panels. You could also throw it out as a text-only prologue or even just flash back to it later. Either way, aim to get stuck into the essence of the story as quickly as possible.

Consider writing a script, if not roughly sketching out the story. You need something to follow to prevent you wandering off track. You may decide to go into detail with it, or keep it quite simple. It should describe what the scenes for each panel look like as well as any speech or dialogue.

Keep in mind the importance of the panel that you'll be drawing. How much impact does the panel carry? In general, the bigger panels attract more attention than smaller ones. Therefore, big panels should be reserved for important scenes that need emphasis while the small ones are used to aid the fluency of the story.

How many panels per page you draw depends on the scene. Around five is typical, with maybe just one to three for more dramatic or action scenes. In Western comics these usually run from left to right, top to bottom. In Japan, manga is read from right to left and the pages are back to front, by Western thinking. Some Western manga ka believe their work should be authentic to both the traditional style and page layout. I feel you should cater for your audience – if the work is intended to be read mostly by a Western audience, provide a style of layout they are more familiar with.

Start with a short story before launching into an epic series. Your first manga might just be a couple of pages or a one-shot story of 20–30 pages. If you've got a million ideas in your head it can be easy to start one then lose motivation and want to try something else, or you might get bored if a single page is taking several days to complete due to a lack of experience.

CRUCIAL QUESTIONS

Before becoming entirely wrapped up in the technical and artistic details of your work, remember to ask yourself:

❯ What will hold a reader's interest in the story? Perhaps characters an audience can relate to or following a character's journey in overcoming adversity in an exciting way.

❯ How can I maintain continuity throughout the story? If something happens at the beginning make sure you refer to it again later on and don't just forget about it.

❯ How can I decide what will happen next? Take your time to plan and don't rush through it.

❯ Storytelling and maintaining enthusiasm for lengthy projects can be your biggest obstacle to overcome, but once you immerse yourself in the story and world you create, it's a lot of fun and very rewarding.

Page Construction: Planning

So, you've looked at other manga you like, you have a story in mind, you know the genre and world it will be set in and you have an idea about who will play the main roles and how their lives may pan out.

I've decided to draw an encounter between a female heroine and a monstrous bad guy. The idea is to create a scene which communicates on multiple levels – in general, I am demonstrating that while a girl walking around in monster country may seem unsafe, this is one girl you don't mess with! Next the panels or frames need to be read in an obvious, systematical order. Typically, the first panel should establish the setting or environment, while the last one should show the outcome of the scene.

Before launching into page layouts, it helps to draw out the main cast. You might decide to illustrate them from multiple angles or displaying different facial expressions. Since I'll just be working on a small strip, a single stand-alone design is sufficient.

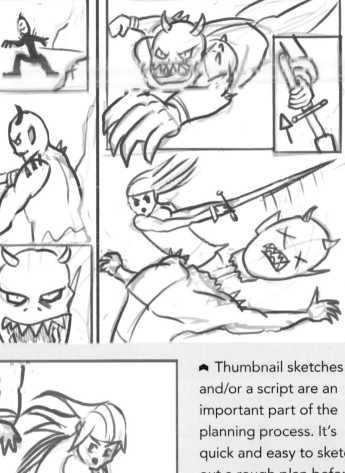

▲ Thumbnail sketches and/or a script are an important part of the planning process. It's quick and easy to sketch out a rough plan before committing more time to a detailed series of drawings. I often try to make panels or character elements overlap, and at different sizes to create a more dynamic and interesting layout.

❮ If I'm not sure about a certain angle or pose, I might try out a few variations, for example, the last frame where the bad guy gets sliced.

Page Construction:
Pencil and Ink Stages

Accomplished artists may be very neat with their pencil work while others will be messier, doing loose sketching, building up page elements, planning out proportions and layouts or drawing and redrawing frames. You may wish to re-trace your work if it starts becoming untidy, or simply make good use of an eraser to keep things clear enough for you to understand and, more importantly, clear enough for your audience to read easily once the linework is refined.

Since you will probably be inking your work after sketching it out with a pencil or graphics tablet, you can choose to be a little messier with it and use the inking stage to refine the details – though my advice is to make your pencil work as neat as possible in your early projects. Using a pen is a process of finalizing a line or committing new details you know beforehand will enhance your image, so use the pencil stage to try new details and flourishes you've not tested out before.

ADDING INK

Varying line weight, hatching or feathering to suggest lighting and shadow is perhaps not as

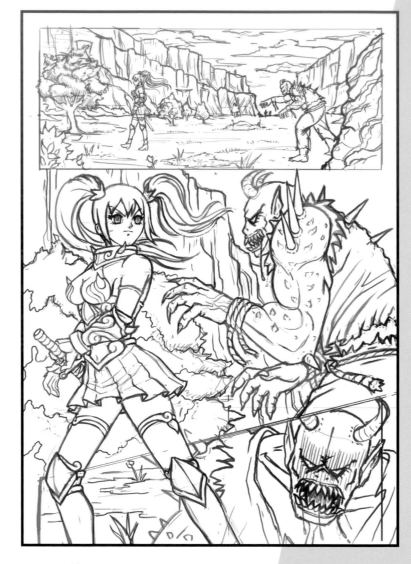

common in manga as in the Western comic industries. A lot of manga will instead keep linework super-fine and use gray tones to add emphasis on certain parts of an image.

In these pages I haven't shown a light source with the inking. I would ordinarily do this by adding block shadow or hatching where light doesn't reach, while making lines thinner the nearer they are to the light source. However, I have thickened the lines around the outside of the characters and objects closest to the viewer to give more depth and focus. If you don't intend on toning or coloring your manga pages, this step will definitely give them a more professional look and help to make them easier to read.

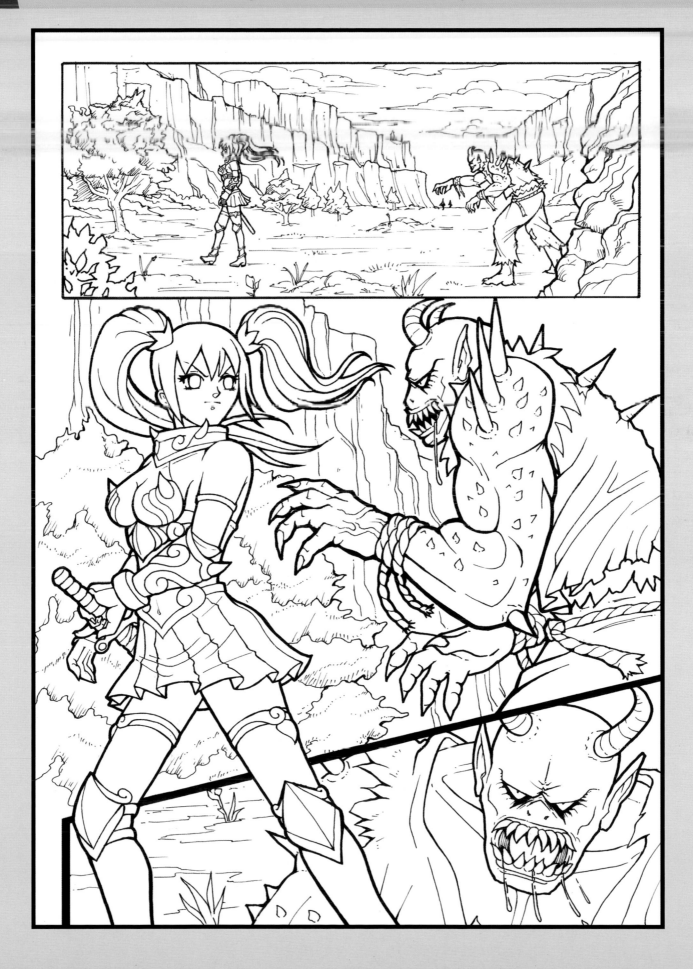

Page Construction:
Gray Tones

Most manga coming out of Japan will use gray tones, or 'screen tones'. These are gray shades or textures laid on top of an image which can be applied fairly quickly to give the artwork an extra sense of depth and detail. Some manga will be quite sparing with these, perhaps with just a basic flat shade overlay here and there, while others might use a range of different gradients, patterns or textures throughout each page, while etching away highlights from the flat or shaded gray tones to produce a white light source.

Traditionally, screen tones are cut to size with a knife and applied using an adhesive sheet on top of the artwork, although nearly all manga these days uses digital techniques to add tone in a fraction of the time.

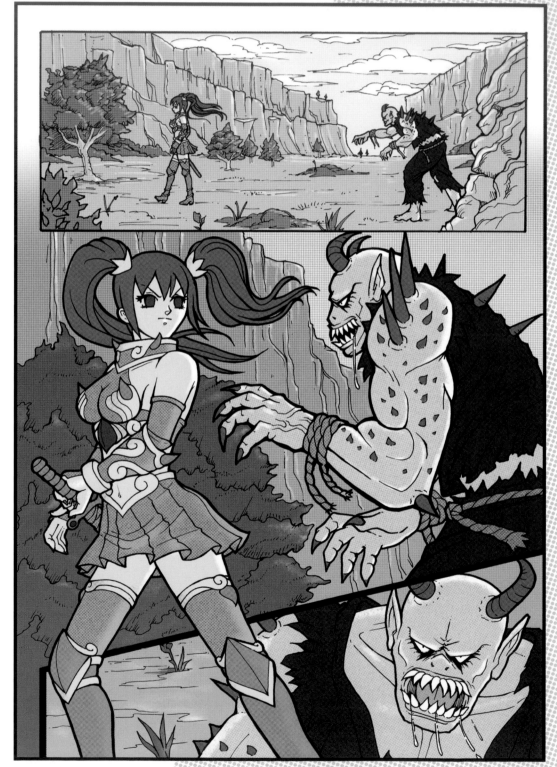

Here you can see I've used a range of basic tones for my manga pages. This was mostly for effect and to add some contrast between the characters and also the background. I've also now moved on to page two, repeating the process of pencil, ink then tone.

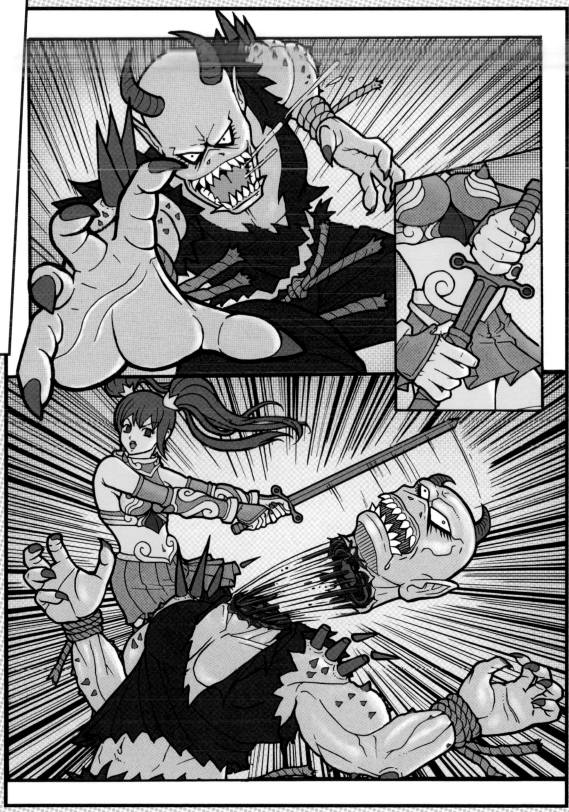

Page Construction:
Color Pages

You might decide to skip the gray tone and go straight to color for maximum effect. This allows you to concentrate a little more on form and lighting, as with previous examples in the book. Note that I've used lighter tones for the girl to help show she's the hero, while the bad guy is in black. Red and orange is used on the action line panel backgrounds to help create a sense of danger and drama.

Even though the scene reads pretty well, I decided to add in a few speech bubbles and effects after I was done just to make it clearer that the monster isn't simply asking the girl for directions!

NARRATIVE TIPS

Think about pacing. It's fine to have more static pages where characters are conversing, but limit these or try to find ways to make them interesting in order to avoid dozens of panels showing the same few characters simply sitting or standing still while having a single discussion.

Consider how to leave as many pages on a cliffhanger as possible. The aim is for your reader to want to turn over the page to see what comes next. For example, a chance encounter with a monstrous bad guy on page one creates tension – how will the girl deal with this? Will she get eaten, injured or have a few tricks up her sleeve, and if so, what might they be? Page two has the answer!

Try drawing your own pages – it's a fantastic way to get the most out of your ideas, characters and creations.

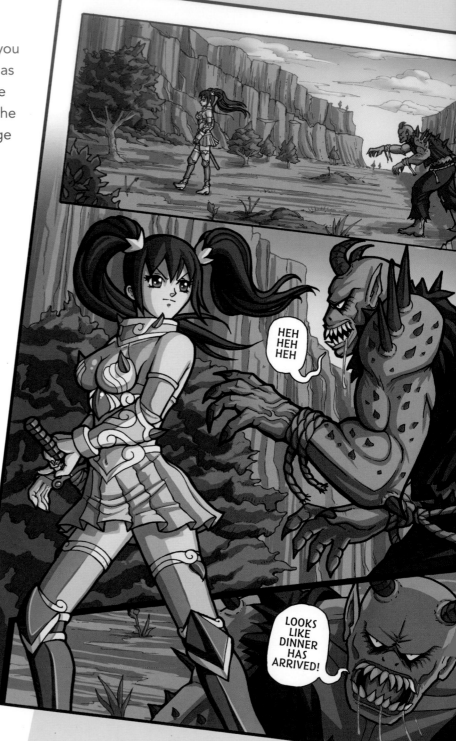

110

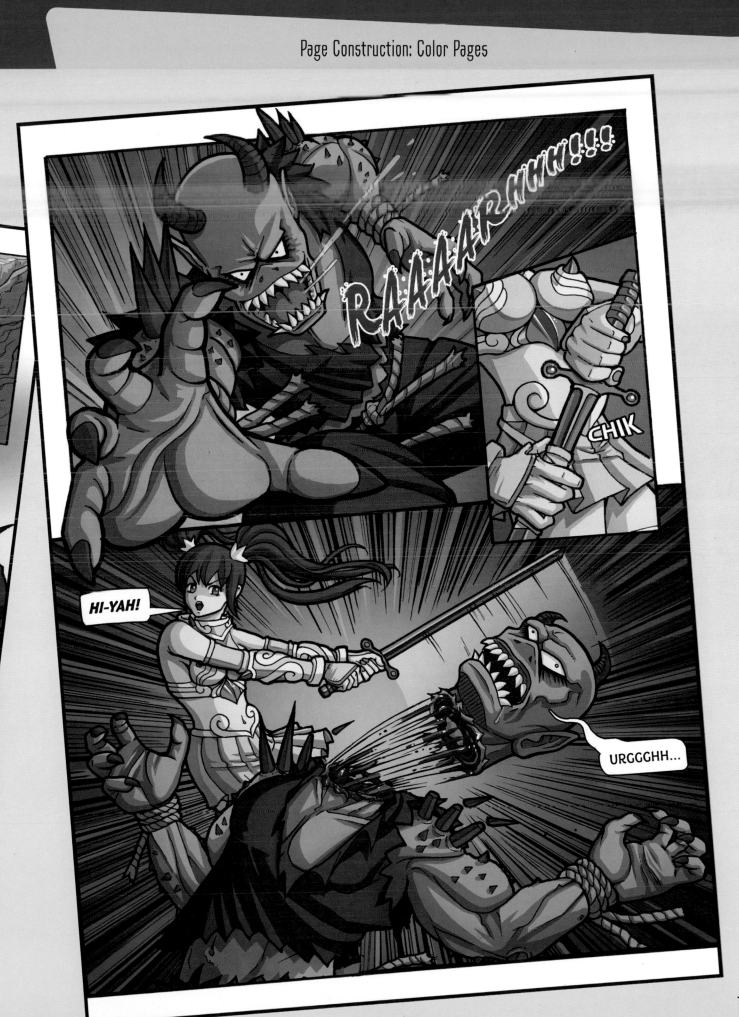

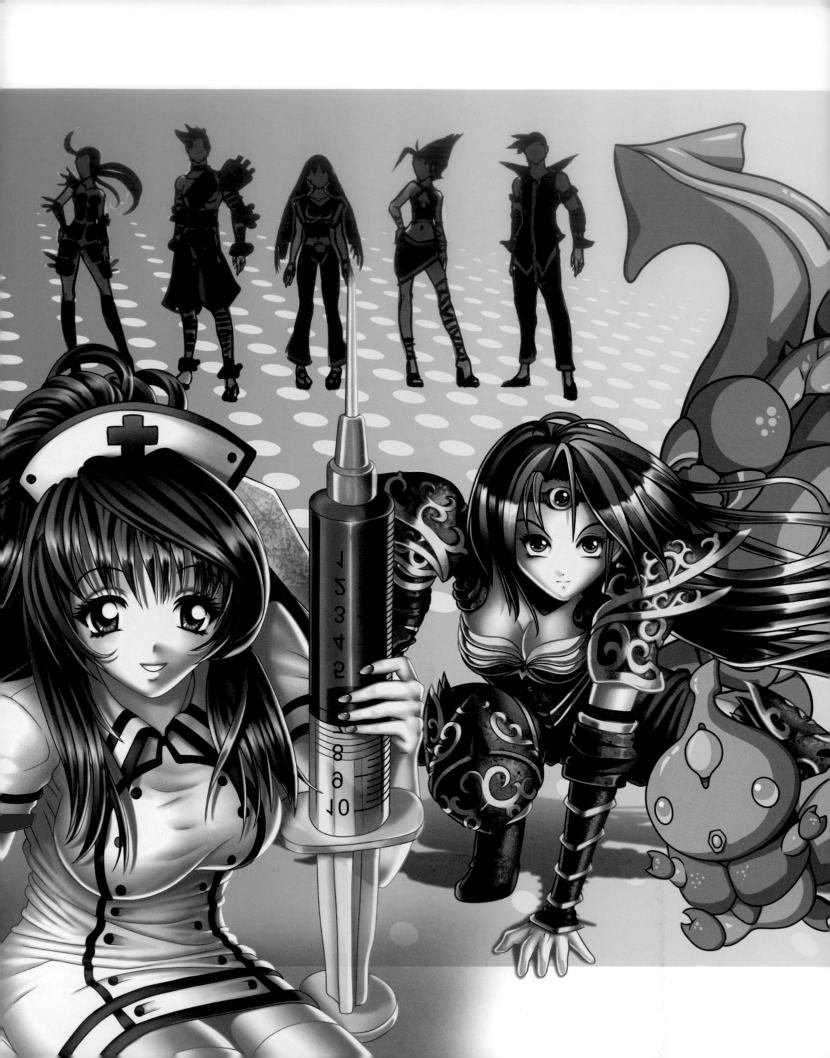

Creating Characters

They can come in all shapes and sizes, male or female, human or not. They may be fun, cool, cute, strong, sexy, funny, interesting, scary or mysterious. There are endless possibilities for creating characters and sometimes it can be fun to just start doodling ideas and see where it takes you. Alternatively, you can decide beforehand what type of character you want to create. Try both methods – the success of each might depend on your mood at the time, or one approach might just suit your way of working better.

There are always multiple ways to reach an amazing end result and you should experiment with as many styles, poses, angles and personality types as you can. While practicing, try focusing on just one element of your concept, such as a weapon or outfit. Here, an unexciting, front-facing pose is perfectly fine. Or, if you're focusing on a dynamic pose or angle, feel free to omit clothing or costume to make the geometry easier to comprehend. As your confidence grows, you can start to bring it all together in an attempt to tackle both an interesting pose and a complex outfit design, along with some detailed rendering and color.

Manga has such a diverse range of genres that it's impossible to demonstrate every type of character you might find, from aliens to animals, mechas, monsters and a range of human characters. However, you are most likely to encounter archetypes such as:

> **School students (as featured in *Deathnote*, *GTO*, *Azumanga Daioh*)**
> **Samurai and ninjas (*Naruto*, *Rouroni Kenshin*, *Bleach*, *Lone Wolf* and *Cub*)**
> **Maids or nurses (*Hand Maid May*, *Welcome to Pia Carrot*, *Maid Sama!*)**
> **Giant robots (*Macross*, *Gundam*, *Neon Genesis Evangelion*)**
> **European Fantasy (*Berserk*, *Full Metal Alchemist*, *Hellsing*, *Attack on Titan*)**
> **Monsters (*Pokemon*, *Digimon*, *Yu-gioh*, *Bakugan*)**
> **Magical girls (*Sailor Moon*, *Cardcaptor Sakura*)**
> **Fight themes (*Dragon Ball Z*, *Fist of the North Star*, *One Punch Man*, *Street Fighter*)**

I'll be illustrating a selection of these in this chapter and encourage you to have a go at creating your own for a chosen genre or theme.

Quick Sketches and Thumbnails

As with a comic-book page, generating an initial rough or thumbnail drawing can be a good way to start as it allows you to quickly consider ideas or plan out a framework for your drawing before committing more time to a final piece. These initial sketches can be messy or reasonably neat, depending on how you like to work. You might just want to use the opportunity to plan out a pose or gesture or work out a detail on the outfit.

You might also use this opportunity to try out new style ideas. By tweaking the eyes or hair or exaggerating proportions you can add elements of realism, cartoon or other comic-book influences to help experiment with a way of representing people.

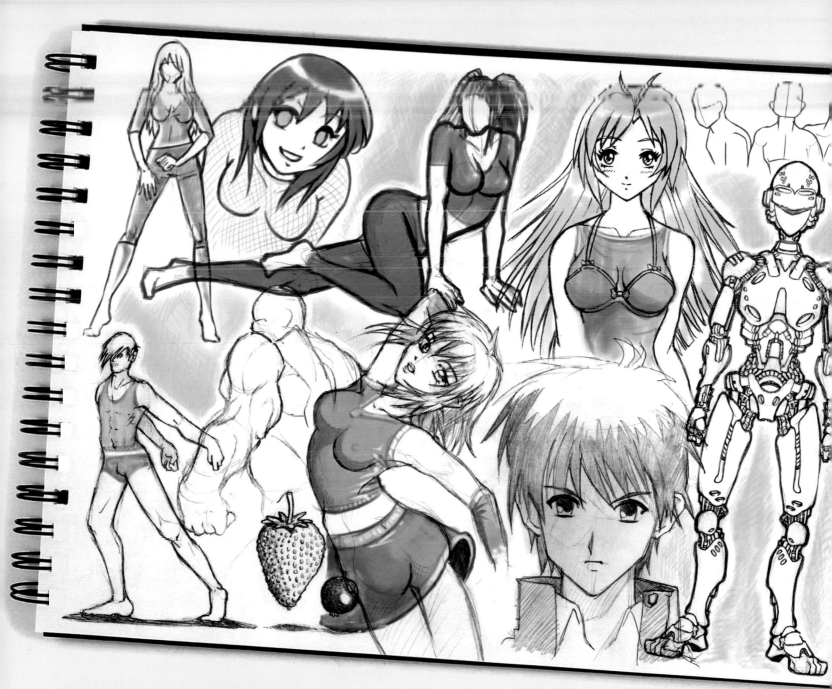

USING A SKETCHBOOK

Keep a sketchbook or rough paper handy for jotting down ideas or practicing your drawing whenever you have free time – traveling on public transport, waiting for an appointment, chilling in front of the TV, or sitting in a park or coffee shop. Make sure each page is filled with as many concepts and practice sketches as you can fit in.

Medieval Warrior

While traditional samurai are featured in numerous Japanese stories, many anime, manga and video game fans are equally keen on European-style medieval fantasy warriors such as those featured in *Claymore*, *Berserk* or *Record of Lodoss War*. The fantasy genre was first introduced to modern audiences by authors such as Tolkien in his Lord of The Rings books, which were based on Nordic and Germanic mythology. Where fantasy worlds are concerned, you can't go wrong with knights, elves and magicians! Here I've drawn a female knight, giving her a dynamic crouching pose, a foreshortened sword and wind-blown wavy hair to add movement. Green, brown and yellow help to communicate her connection to nature, while the gold trim denotes a higher rank of knight.

 After planning the outfit, I drew some thumbnail sketches to help me decide on a pose to use, then drew over the top of my preferred sketch to refine the design.

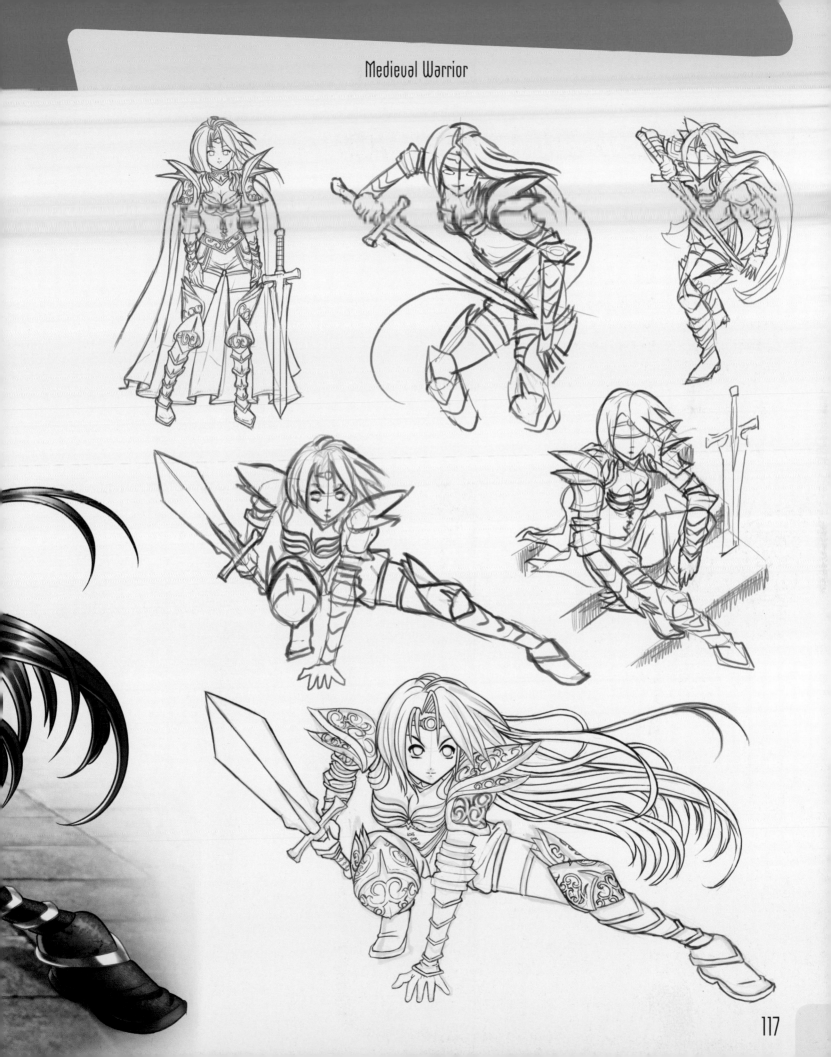

Medieval Warrior

Japanese Nurse

In the fictional world of manga, oversized instruments or accessories can be used. A syringe, scissors or perhaps a scalpel would be suited to someone working in the medical profession; if you were drawing a mechanic they might be holding an oversized wrench or spanner, or an artist like yourself might make use of a super-large pencil or brush. I wanted to give this character a short back-story, which I could then consider when planning further scenes or scenarios.

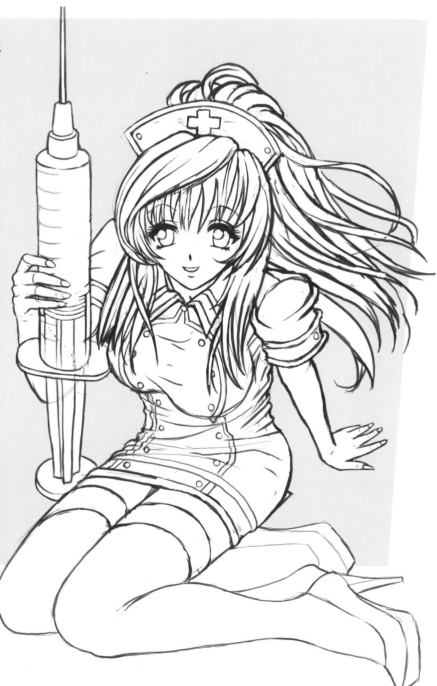

Name: *Miyu Kitagawa, age 21.*

Likes: *Sushi, marshmallows, cosplay, taking care of patients and delivering good service.*

Dislikes: *Viruses, diseases and germs.*

Bio: She recently started work at a newly opened hospital in Tokyo and shares a small apartment with two friends. She's kind-hearted and always aims to help her patients while putting a smile on their faces. She can be clumsy, though, with habitual knocks, spillages and tripping over, which causes patients, staff and visitors to jump out of her way to avoid being stabbed by her syringe! She's cute, but potentially dangerous.

ALTERNATING COLORS

Before coloring your inked linework, consider making copies. This will allow you to experiment with color combinations or shading before committing to a final image. If you're working digitally, try out new color combos after you've finished rendering by changing the hues of different layers.

Manga Monsters

A lot of the monsters featured in *Pokemon* are based on existing animals such as birds, reptiles and various land-dwelling mammals, so consider using real-life species as a starting point when you are developing a new type of creature. I wanted to create a character that was insect-like, but also aquatic – a waterbug type.

Likes: *Water, challenging other creatures, blue-colored things such as blueberries and the sky.*

Dislikes: *Fire and heat, ice and snow, high places, losing fights.*

Bio: This is a sektar. Sektars live in large lakes and rivers, feeding on small fish and water weeds. They can be over-confident, wanting to battle larger enemies but sometimes losing, after having bitten off more than they can chew. They are moderately intelligent despite their drive to rush into dangerous situations which can get them into trouble. They lay eggs which hatch and evolve through four incarnations, increasing their power level as they gain battle experience. The more they grow, the stronger and more confident they become.

Special powers:
- Bug Bite, using his powerful pincers to nip at his foes.
- Water Blast, spitting a jet of water from his mouth to push enemies aside.
- Tail Stomp, whereby the sektar hammers his tail to the floor creating a vibration frequency capable of shocking an opponent's nervous system and freezing them in their tracks.

STAGE 2

STAGE 1

EVOLUTION OF A SEKTAR:

Starting from top to bottom. Perhaps they have a fifth stage of evolution. What might that look like?

STAGE 3

STAGE 4

Creating a Mecha

Manga robots, or mecha, can be seen as humanoid-looking or mechanical and tank-like, or somewhere in between. Most of the time they are designed for combat purposes, fighting against armies, aliens, monsters or other mecha. They can be the same size as an average human or big enough to tower over cities.

BACK-STORY

This is Unit 56A01, otherwise known as Novas Arma, a creation of the military-funded AMP (Assault Mech Project) organization. In 2085 AMP was assigned the task of developing prototype technologies capable of defending Earth's inhabitants from a race of hostile alien invaders.

While the war between Earth and the aliens raged on for a few short years, AMP began development and manufacture of their weapons to assist the planet's defense force. However, their production facility was attacked and destroyed by the aliens before Arma was ready for testing. Due to the dire situation of the Earth's defense force, it was decided that Arma be deployed into battle straight away.

This new mecha proved effective in battle against the aliens, although due to excessive heat build-up it experienced sudden power shortages if in use for more than a 30-minute time period, leaving the unit vulnerable to attack.

With a new wave of alien adversaries on their way, Arma is Earth's only hope of survival. Will AMP be able to build a new production facility to enable improvements to Arma's power systems in time?

ARMAMENTS

Novus Arma carries two powerful pulse-beam hand guns, allowing it to fire at multiple enemies simultaneously without the need for heavy machine guns or rifles, making it fast and maneuverable. It has twin missile cannons mounted to the rear for extra firepower. AG (anti-gravity) boosters attached to the waist allow mid-air combat.

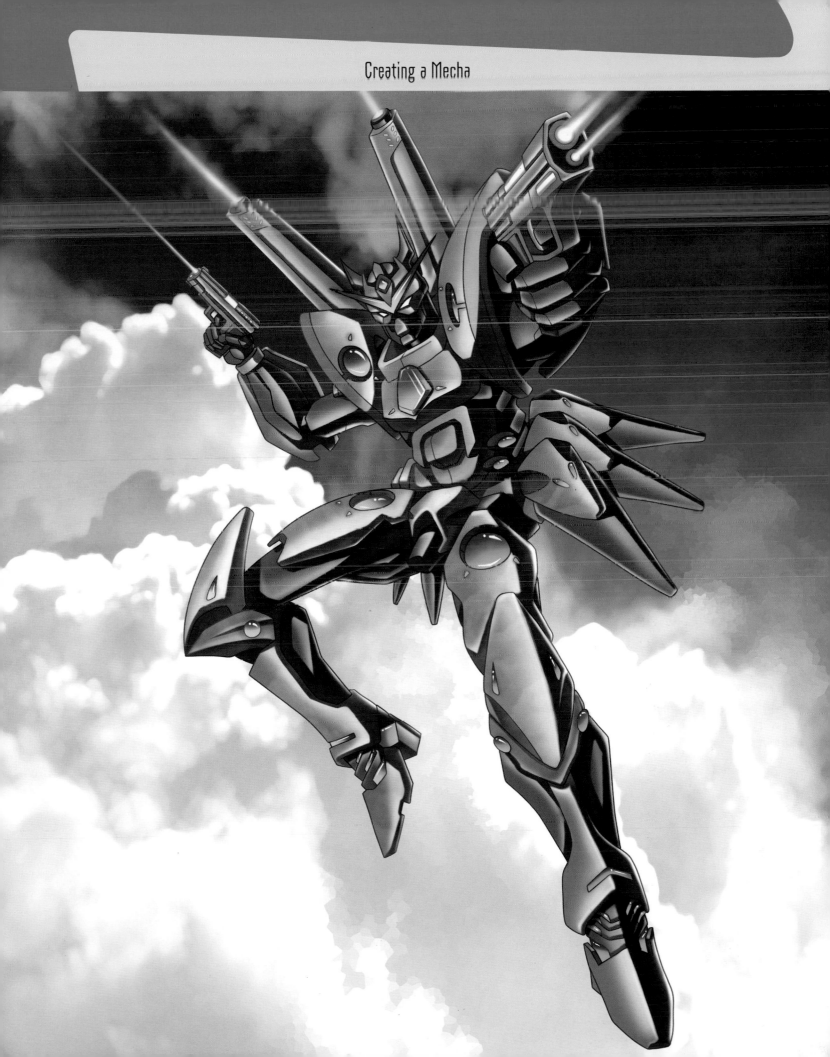

Art Questions and Answers

> How long should I spend on a picture?

It depends on the size, amount of detail and your general drawing pace. Speed is usually determined by consistent practice and experience. I spend extra time on my own works to get rid of the brush stokes, ink bleed and stray pencil marks, but that's just my perfectionist attitude. Many other artists would bypass this stage, saving themselves hours but still getting something which at first glance looks to be of a fairly similar quality.

Don't be scared to work on a drawing for more than an hour. If you want to progress, take time to make sure everything looks real and if you're adding a background, don't rush it. If you're doing manga or comic sequential pages, be prepared to spend anything from three to 12 hours penciling alone. Be patient with your picture. If you're getting sick of drawing, leave it for a while and come back later.

> I can't find time to practice. Any suggestions?

You need to make time to draw, which might mean giving up something like half an hour of TV or internet browsing. Or you could try drawing while on public transport or waiting for an appointment. By drawing on a regular basis over time, it will become a habit and finding time will no longer feel like a problem.

> I REALLY wish I could draw, but for the life of me I can't. Does anyone else feel this way?

Don't worry. All artists have at some point felt limited by a lack of ability. If you haven't been drawing regularly up until now, I'd be amazed if you could draw well. It's something that will take time and practice to improve upon and you should allow yourself as much time as you need to get better at your craft. For some people, it might be a matter of weeks before they start to see improvement, while others might need several months or years.

It's tempting to compare yourself against other artists who are at a higher level than you and feel defeated after pouring hours of effort into your work and not getting much, if any, recognition for it. However right now, rather than chase praise, likes, favs and follows, your mission should be to improve your skills and enjoy creating in the process.

> How long will it take me to become a master artist?

It's been said that to master any skill takes 10,000 hours of practice. Clocking up the hours will increase your skills as your brain begins to retain the knowledge and experience that comes from each new drawing session. That doesn't mean you can't create a great-looking picture after only 100 hours of practice. I don't think about the hours I 'should' be putting in – the main focus is to learn from each image you produce and to have fun trying out ideas and creating the types of characters or artwork you enjoy.

> I'm struggling with too much detail. What can I do?

Simplify your art to match the level you're at. Beginners might find some of the final images in this book too complicated at first, so by all means cut back on details. For example, clump hair into fewer spikes, remove the trim or fiddly detail on clothes or leave out folds and concentrate on basic body shapes. Take it all step by step – work on stick figures and basic shapes first so you don't feel overwhelmed by the final image. Lastly, be patient. Before thinking 'There's no way I could draw that' or giving up after a matter of minutes, take your time and know that a good drawing can take a long time to create and you'll learn to speed up as you improve.

> Should I post my artwork online?

Putting your work on the web is a great way of getting feedback. Online art communities will provide a platform where you can show what you've created and gain critiques from other artists who may be able to see where you need to improve. It can be daunting, because there's always the possibility of a troll

unloading some negativity or you might simply get your feelings hurt if another artist isn't particularly tactful in their evaluation of your image. However, most artists want to help others and can impart invaluable insights.

How can I draw...?

If there's a particular area you're having trouble with, such as buildings, people, animals and so on, the best thing to do is find reference material from the web or take some photos. If you've never drawn a cat, for example, try a few pictures of cats from a photo, so you get used to exactly how cats look and move, then draw your own cat picture based on previous doodles. The more you practice any single object, the easier it is to draw it again next time.

Where's the best place to draw?

Anywhere you feel comfortable. Some people set aside a room in their house for the purpose, some use their bedroom, others take their sketchbook to the local café. I've been known to sit around the house in different rooms with a clipboard and paper, or draw at a library, a pub, a coffee shop, waiting at a train platform. However, I spend most of my time creating artwork in my dedicated studio and listen to music, audio books or YouTube meanwhile. If you'll be drawing frequently, a dedicated workspace is essential for long-term comfort.

I want to sell my work – what should I charge?

Pricing work is never straightforward; there are dozens of factors to take into consideration. Some of the main ones are:

- **What is your work worth to you? All work takes time, effort and skill.**
- **How does your work compare to that of professionals?**
- **Who is paying and what will the work be used for? This is very important, as individuals will only pay so much for a private commission, whereas companies looking to use the character in a game or as a company mascot are usually willing to pay a much higher amount.**

Starting up as someone who draws for money is hard at first as you need to understand business matters as much as how to draw well. Be strict with your pricing and don't undersell yourself as you'll just feel ripped off if you end up taking extra days over a picture and feel you weren't properly compensated for your time. However, if you overcharge you'll never get customers! It's a tricky balancing act. Price only at what you feel comfortable with.

Are there any universities that teach manga and anime?

Most countries have places of education running dozens of illustration and animation courses every year. This is something you'll have to research yourself to find out what is available in your locality. See if you can find reviews for those establishments you'd consider attending, or better still have personal contact with their students, since the quality of education you can expect to receive will vary greatly from school to school. There are several online schools which offer art instruction and guidance. They may be focused on general art techniques or more specific courses such as animation, illustration, concept design, and comics. There are also a few schools dotted around the globe which specifically focus on teaching manga.

How can I develop and maintain a drawing style?

The more you practice the same style, the more it will lodge in your memory and will become part of you. If you're like me, you'll be constantly seeing other styles you like and want to imitate and so following one style can be hard. Style is something that any artist will continue to develop and it is also something that comes naturally. Don't try to force a style to happen. Just let it develop over time.

Glossary

Action lines
Used in manga as multiple straight, parallel 'speed lines' to denote movement, or a circular arrangement of 'focus lines' to draw attention to an object, person or element on a page.

Airbrush shading/soft CG
A style of digital art which uses smooth, blended tones like those of a traditional airbrush.

Anatomy
The structure of the body and how the various parts are in proportion with one another.

Anime
A Japanese style of animation and artwork.

Background
The area of an artwork that appears farthest away from the viewer; also, the area against which a figure or scene is placed.

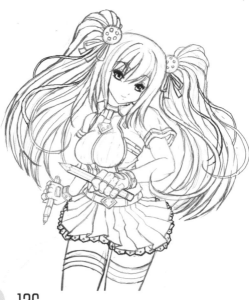

Cel shading
A style of artwork like that of an animation still, which uses solid tones and shading.

CG
An abbreviation of 'computer graphics', often used to describe digitally rendered manga art. CGing is the process of rendering artwork digitally.

Chibi
Small, cute style of characters, often drawn with large heads and small bodies and limbs.

Commission
To request, or the request for, the production of a work of art. Artists interested in earning money from their artwork take on commissions from individuals.

Composition
The arrangement of the individual elements within a work of art which forms a unified whole.

Contrast
The range of light to dark areas in the composition. An image with high contrast will have a greater variability in tonality while an image with low contrast will have a more similar range of tones.

Cosplay
The act of dressing as one's favorite characters from anime, games and films, usually at comic conventions and events.

Dojinshi
A fan comic based on an existing story, setting or characters.

Flatting
Or 'adding the flats'. The process of adding a solid, flat base tone to layers on an image, often within predrawn outlines and line art.

Foreground
The area of an image that appears closest to the viewer.

Graphics tablet
An input device which connects to your computer, allowing you to draw with a pen or stylus instead of a mouse. Often simply referred to as a 'tablet', not to be confused with a tablet computer.

Inking
Adding clean black outlines to an existing pencil or graphics tablet sketch using traditional media or computer software.

Layers
Most graphics software uses layers. They act like sheets of stacked glass – you can see through transparent areas of a layer to the layers below. You can move a layer, repositioning its content, like sliding a sheet of glass in a pile. The opacity of a layer can be altered to make the content partially transparent.

Layout
The arrangement of the elements within an image or comic page such as the panels, speech balloons, and gutters or margins between elements.

Mecha

Abbreviation for 'mechanical'. Mecha are machines and most commonly robots as well as being a genre of manga.

Medium

The material used to create a work of art, for example pencil, ink, acrylic, digital.

Middle ground

The part of the picture that is between the foreground and background.

Monochrome

Having only a single color.

Panel

A single frame or drawing in the multiple-panel sequence of a manga or comic-book page. It is an individual drawing depicting a captured moment in time.

Perspective

A technique used to depict a three-dimensional object or environment, as in an illustrated scene that appears to extend into the distance.

Photoshop CS & CC

CS stands for Creative Suite; CC means Creative Cloud. Photoshop is one of several Adobe programs. The tutorials in this book are based on Photoshop CS6 and CC.

Render

A term meaning 'add shading' by, for example, adding shadow to depict the form and shape of an object.

Reference

Typically images and photos which assist an artist to generate ideas or understand what something looks like in real life.

Scanning

Importing images and artwork into your computer and converting them to a digital format. An alternative to scanning might be to photograph artwork and transfer it to the computer.

Shading

Adding darker or lighter tones and values to create the effect of shadows, highlights and three-dimensional forms.

Shonen

Manga catering for the teenage male demographic. Seinen manga caters for young and older men.

Shojo

Manga for the teenage female demographic. Josei manga caters for older women.

Stock image

Often a photograph that is licensed for specific purposes. It is used to fulfil the needs of creative assignments instead of hiring a photographer or drawing parts of an image manually. Stock images come with terms of use – if you are paying for such images you may be able to use them in whatever way you please. Royalty-free or no-charge images often require you to give credit to the owner or provide a link to the image source.

Tone

A term used to describe a hue and the result of mixing it with any shade of gray.

Workflow

The process an artist goes through to achieve his or her results from start to finish or from one step to the next. The more efficient your process, the better your workflow.

Thanks for reading. Now it's time to grab a pencil and some paper, stick on your favorite tunes, start drawing and have fun!